D

ROYAL ACADEMY ILLUSTRATED 2010

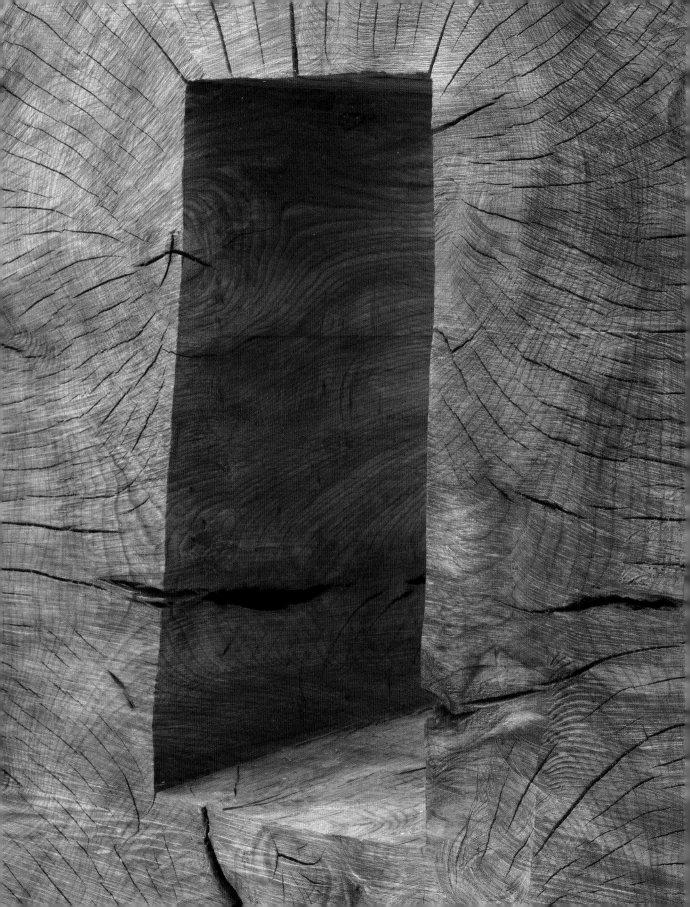

A selection from the
242nd Summer Exhibition

Edited by Stephen Chambers RA

ROYAL ACADEMY ILLUSTRATED 2010

SPONSORED BY

Insight
INVESTMENT

➤ A BNY MELLON COMPANY℠

ROYAL ACADEMY OF ARTS

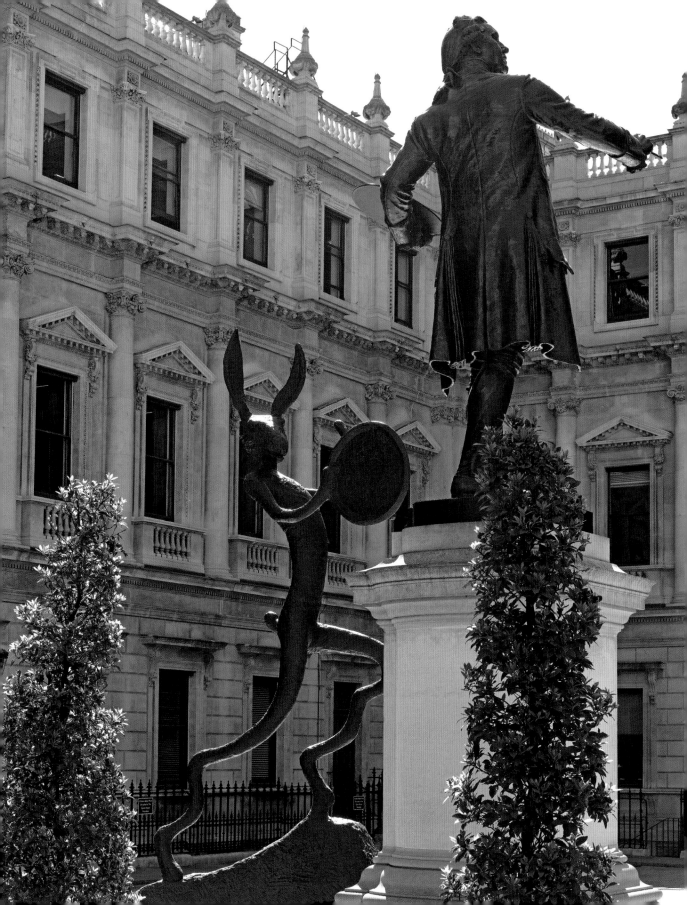

Contents

Sponsor's Foreword

Insight Investment is delighted, as lead sponsor, to continue its association with the Royal Academy of Arts and the artistic talent for which the Summer Exhibition is widely renowned.

Insight is a specialist asset manager at the forefront of building investment solutions designed specifically to meet its clients' evolving needs. Launched in 2002, we have grown to become one of the largest asset managers in the UK, winning industry recognition for our investment capabilities. Our investment platform has been built to give complete flexibility across a broad range of asset classes, an essential tool in providing tailored client solutions. With well-resourced, highly skilled teams, we aim to achieve consistent and repeatable returns. We cover the entire risk/return spectrum, offering our clients absolute or relative return performance benchmarks.

Our ongoing partnership with the Royal Academy is driven by two shared values: innovation and creative thinking. Innovation is key to the development of our investment capabilities and as leaders in our particular areas of expertise we continue to look for opportunities to expand our business to reach new clients. For us, creative thinking is about breaking ground, challenging convention and thinking boldly and differently in everything we do, qualities that are in abundance at this year's Summer Exhibition.

This is now our fifth year of sponsorship and we very much hope that visitors to the exhibition, along with our clients, business partners and colleagues, will find new sources of inspiration in the works on display.

More insight. Not more of the same.

Abdallah Nauphal
Chief Executive Officer

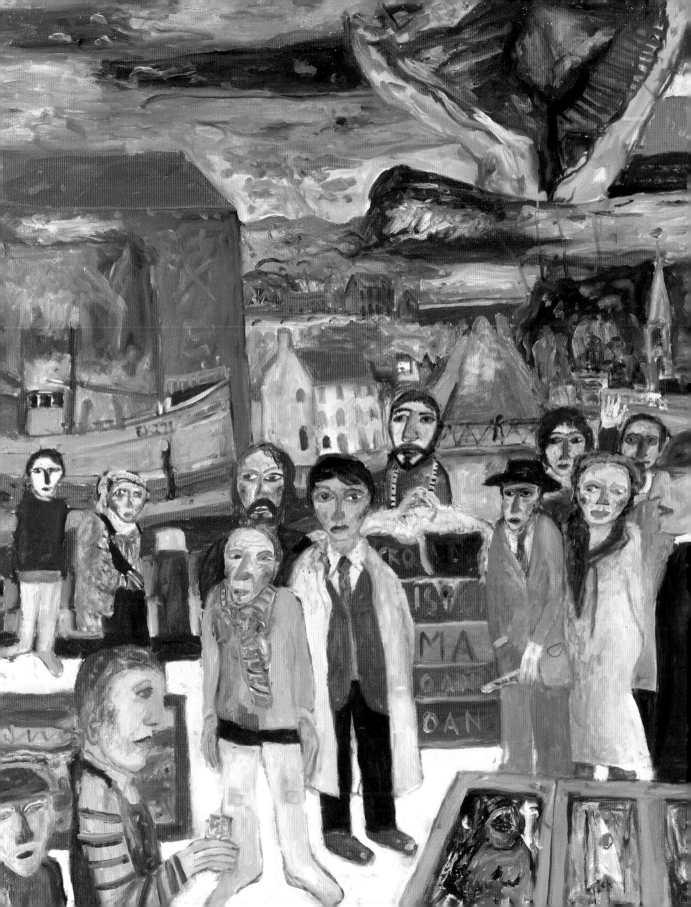

Introduction
Richard Cork

Nothing could be further removed from old-fashioned gentility than the abrasive word 'raw'. But quite unexpectedly, it is the overriding theme of the Royal Academy's 242nd Summer Exhibition. And this feisty, heretical word succeeded in attracting 11,000 submissions from enthusiastic artists across the nation. A century ago, most Academicians would have felt affronted by the very idea that their work was lacking in gloss. Today, however, 'raw' – signifying vitality, risk-taking and a necessary sense of adventure – has been greeted with widespread approbation.

The theme was chosen by Stephen Chambers, the main co-ordinator of this year's show. Fired by the conviction that 'art can be rugged. Paint is essentially coloured mud spread across cloth, and sculpture is made of "stuff"', he wanted to 'push the exhibition in curious directions'. According to Chambers, raw art is 'fresh, new, visceral and affirmative. Some of it is fairly scary, too.' He is fascinated above all by 'artists who are mavericks, people who don't play by the rules but plough their own furrows'.

Wherever we roam in this uninhibited show, Chambers has inserted a work by an artist bent on taking us by surprise. Some are big and robust, others intimate. Their creators range from young artists like James Fisher, just out of art school, to those as eminent as Nancy Spero, who recently died. Chambers wants these works to 'pull visitors through the galleries', and nowhere more explosively than in the Wohl Central Hall, which Yinka Shonibare's *Crash Willy* invades with the aftermath of a car accident. 'This is a pretty big and nutty piece, but fabulous,' says Chambers. 'The driver looks as if he has come out worst from a Wacky Races prang.' But 'raw' can also embrace the far more spiritual charge informing Bill Viola's video *Acceptance* in Gallery X, where water falls on a naked woman. 'It's drenching her, and she doesn't have much choice. But there are religious undertones: it's a kind of filmed late baptism.'

David Chipperfield, the co-ordinator of the Architecture Room, also warmed to the idea of 'raw'. Shifting the architects to a bigger gallery, the Lecture Room, he set about exploring the creative origins of architecture rather than glossy outcomes. 'I wanted to focus on concepts rather than final representations of buildings,' Chipperfield explains. 'This is much more speculative and interesting. I wanted to show the plurality and diversity of what architects see.' Chipperfield admits that 'architects don't like to show their rough stuff, so you have to winkle it out of them'. But he has succeeded in curating a so-called 'Arty' section, with works by several practitioners, which seems to be exploding with sculptural forms.

The President of the Royal Academy, Nicholas Grimshaw, is displaying his proposal for a high-speed railway station in an ancient setting outside Naples, beside Vesuvius. And other architects are confronting similar challenges in historic locations, such as Bath, where Eric Parry has designed an impressive extension to the Holburne Museum of Art. Foster and Partners are displaying four spectacular versions of their proposal for a tall white India

Georg Baselitz Hon RA
Mittendrin (detail)
Oil
272 × 202 cm

8

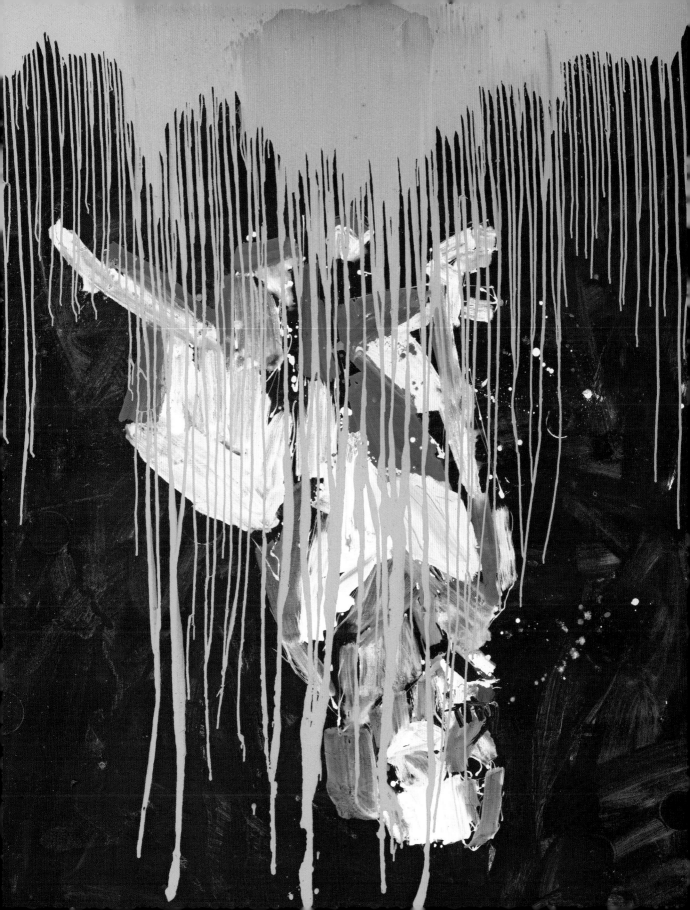

Louise Bourgeois
Ladders
Etching
30 × 25 cm

Gary Hume RA
Bikini
Silkscreen
60 × 40 cm

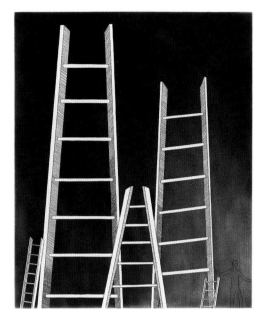

Tower in Mumbai, while Renzo Piano shows his *Façade and Roof Study* for the Art Institute of Chicago.

The theme of rawness in contemporary painting gives Gallery I an extraordinary sense of energy. Arranged with flair by Allen Jones, who enthusiastically calls it 'the room of scribbling – the paintings here are all about expressionist gesturing', its largest exhibit is a colossal, wildly handled five-part painting by Jeffery Camp. Maurice Cockrill's rhythmic, lyrical abstraction enters into a fruitful dialogue with works by Albert Irvin, and with John Hoyland's commanding *Memories of Rain*, drenched with a dramatic downpour of streaming paint.

By no means all the work on show is splashy. In Gallery II, the end wall is dominated by two large, buoyant and arresting paintings by Michael Craig-Martin. He juxtaposes ordinary objects with words in upper-case letters, which in the biggest painting spell PARADISE. But no words can be detected in the mysterious painting by Emma Biggs and Matthew Collings, called, tantalisingly, *The Unseen*. Nearby, David Nash wholeheartedly engages with the exhibition's theme in *Raw Elm Frame*, a chunky block of cracked, ageing wood resting its formidable weight on an equally robust base.

Rawness in the Large Weston Room can be found in the work of the 98-year-old Louise Bourgeois, and in an enormous print by Stephen Walter, a nightmarish map of London in which the city's streets and buildings are crushed together in a cosmopolitan frenzy. Eileen Cooper, who hung the room, contributes strongly defined linocuts showing a woman taking off her clothes. And Gary Hume celebrates the naked body in his sensual *Bikini*, a co-edition made with the RA Schools, who will receive half of the profits from its sale.

Abstraction at its most exuberant fills the end wall of Gallery III, where six paintings by Gillian Ayres have been hung. Expansive and celebratory, they are charged with the powerful vitality of an artist who was 80 this year. But figurative art is defiantly upheld by Humphrey Ocean's freely painted gouache portraits, Tony Bevan's gigantic picture of his own head looking upwards, his neck strained in yearning, and a poetic painting by Stephen Chambers of a youth gazing at a boat garlanded with flowers. Elsewhere in this immense room, Ed Ruscha juxtaposes a mountain with a blanket, while the 'raw' theme is dramatised by Georg Baselitz, who makes a great splash of blue fall across a helpless, upside-down dog.

Fiona Rae, who has curated a room in the Summer Exhibition for the first time, invited a fascinating range of artists to display their work in Gallery IV. She felt 'very honoured and quite scared' by the experience, but in the end was 'delighted by the overwhelmingly positive response from the artists I approached'. The display vividly reflects Rae's interests as a painter, focusing on artists who conjure up 'fantasy worlds or fictional spaces, with a strong abstract component'. The most alarming work is Nicola Tyson's *Running*

James Fisher
You Won't Hear My Step
Oil
138 × 152 cm

Richard Wilson RA
Shack Stack
Polyurethane resin
H 60 cm

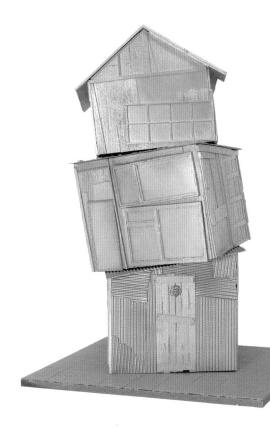

Figure, whose neck appears to have been cut off, while Nigel Cooke's *In Da Club – Me Time* is eerily nightmarish in feeling.

But Cecily Brown's paintings are fired by energetic gestures, and Fiona Rae's love of Japanese cartoons and animated films informs her choice of Hiroe Saeki's intricate pencil drawing of 'strange flora and fauna inventions'. A Japanese influence can also be detected in Rae's own exuberant painting *I Wish to Fully Grow My Small Dream*, whose title is based 'on a quote that I found in Japan. I went to a store in Tokyo called Kiddy Land and got stickers of angels.' Dan Perfect's spectacular painting justifies Rae's belief that 'artworks really take off when the abstract and formal values are dancing alongside the image', so that 'one's understanding flips back and forth'.

The 'raw' theme returns in Gallery V, where Ann Christopher's sculptural drawings have a cutting-edge power and Cornelia Parker focuses on a subject as grim as Reggie Kray's funeral. John Maine's granite discs, piled up dynamically, enter into a dialogue with Richard Wilson's garden sheds, precariously stacked on top of each other. But nothing in the exhibition is quite as overwhelmingly monumental as Anselm Kiefer's painting in Gallery VI. *Einshüsse* shows a massive mountain range punctured by pinkish-orange holes from which pigment oozes down towards burned-out fields, their charred crops resembling battered victims of war. Kiefer's tragic vision could not be more distant in mood from the crisp, dancing vitality of Paul Huxley's paintings nearby.

Sculpture dominates our attention in Gallery VII, where David Mach's *Silver Streak*, made of coathangers, is a King Kong-style monster roaring and beating his chest with aggressive pride. As for Bill Woodrow's arresting sculpture, *Revelator 5*, it dramatises the plight of a bearded man trapped helplessly in a labyrinth of branches that cover his eyes. The most controversial talking point in Gallery VIII is a big, undoubtedly 'raw' painting: Tracey Emin has scrawled 'But I Love You' in blood-red capitals, along with the bewildered words 'Sometimes I Don't Think'. As if in response, Anthony Green's large, multi-angled painting bursts outwards from a self-portrait seated calmly at its centre.

David Hockney's immense, panoramic photo-works preside over Gallery IX, exploring the seasonal changes to one stretch of road in Yorkshire. The road ends up stark and cold, with a substantial covering of snow. Photographs can also be found in Gallery X, where Edward Burtynsky offers a close-up of a car-tyre dump and an aerial view of an industrial wasteland. But painting reasserts itself in the same room when John Bellany presents an enormous stingray, Philip Sutton unleashes very hot colours, Barbara Rae enhances her Celtic landscape with splashes of gold, and Frank Bowling's tall painting, heavily impastoed, reminds us of an enormous boiling sun. Stephen Chambers comments excitedly: 'It's the artist's equivalent of Phil Spector's Wall of Sound!'

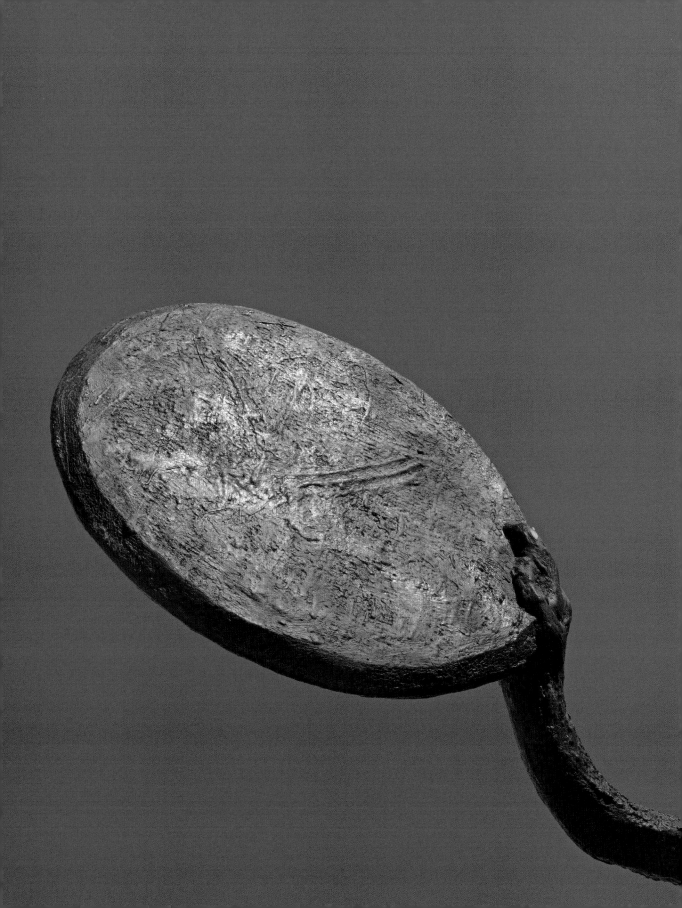

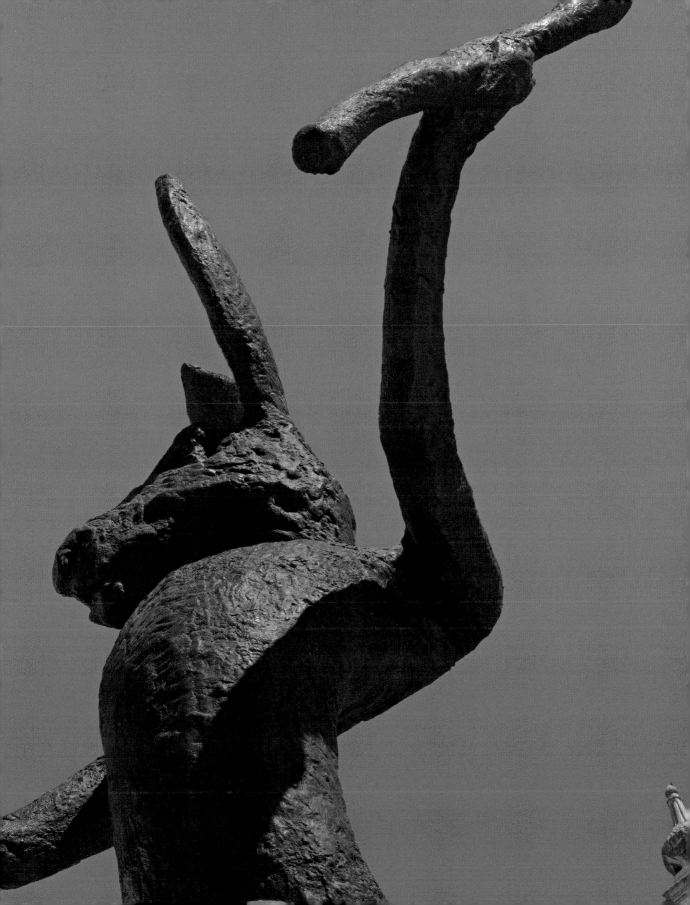

Tributes

Sadly, eight Academicians have died in the past year. As a special tribute to these artists, the RA has opened up the entire suite of the historic John Madejski Fine Rooms for a celebratory display of their work. An extension of the Summer Exhibition, the display is free to all the Academy's visitors. The curators wanted to move away from the notion of a memorial in order to emphasise that many of these artists – Donald Hamilton Fraser, H. T. ('Jim') Cadbury-Brown, Flavia Irwin and, above all, Freddy Gore – were highly influential in making the Academy what it is today. The images on view, which include the artists' Diploma Works – representative examples of their output presented to the Academy on election – show just how distinctive and unforgettable their work really was.

Landscape lay at the very centre of Donald Hamilton Fraser's work. His *Train in the Desert* concentrates mainly on the vast emptiness of sand and sky. A large and dramatic painting, *Golan Memorial, Israel*, contains an immense orange sky with a pale light running through it, while below a black pyramidal form thrusts up like a weapon. Freddy Gore was likewise attracted to Mediterranean landscapes at their most warm, sunlit and fertile, proudly following in the tradition of Van Gogh and the other Post-Impressionists. But he was fascinated by urban life as well. In the late 1940s he painted *Outside the Cinema, Charing Cross Road*. Here, while a man plays an accordion, a young woman and her companion dance on the hot orange pavement, and two 'spivs' discuss some dodgy deals beside the cinema's ornate, multi-coloured entrance.

Flavia Irwin's consummate paintings are, by contrast, far more spare, structural and abstract. She knew precisely how to pare a subject down to its essential forms and colours. Executed in acrylic, Irwin's paintings have intriguing titles like *Diffraction 5* and *Light Definition*. They show her fascination with landscape, luminosity, purged understatement and lyrical analysis of form. She shared an involvement with abstraction and a taste for impulsive, dancing movement with Michael Kidner, who worked right up to the end of his life and left fresh works on the walls when he died. These last drawings are even more abstract than Irwin's, filled with floating forms and restless shimmering dots. But his 1978 painting *Relay* is equally poised, graceful and weightless.

Craigie Aitchison was much preoccupied with the Crucifixion. He returned to this image of tragic suffering time and again, managing to restate it in different ways and place it in landscapes that haunt the imagination. He was able to emphasise the loneliness of Christ by isolating Him against vast, empty terrain. Abstraction plays a part here, but Aitchison could paint a single tree with great conviction as well.

John Craxton's work was more representational, and he was not afraid of detail. His picture of a remote mountainous landscape on Crete finds room for the forms of several animals making their way across the bare earth. But Craxton also had an eye for simplification, and his work testifies to a love of distant locations mysteriously impregnated with history.

Exhibits by the architect Jim Cadbury-Brown make us aware of his enduring fascination with structure. He also enjoyed setting up a dialogue between curved forms and rectilinear geometry, revealing the rewarding tensions between them. Barry Flanagan was preoccupied, in his later years, with animal vitality. His small sculpture of an elephant is on display. And the blinds are open, giving us a view onto the Annenberg Courtyard. Visitors can look down from Flanagan's elephant and see, through the windows, his bronze hares leaping and dancing below. They are, above all, an affirmation of life at its most agile, instinctive and zestful.

**Donald Hamilton Fraser RA
(1929–2009)**
Korazim II, 1963
Oil
148 × 110 cm

Michael Kidner RA
(1917–2009)
No Thing Nothing 2009
Coloured pencil
107 × 162 cm

Craigie Aitchison CBE RA
(1926–2009)
Crucifixion 1988/89
Oil
61 × 48 cm

Frederick Gore CBE RA
(1913–2009)
Olive Trees, Les Baux de Provence
Oil
60 × 80 cm

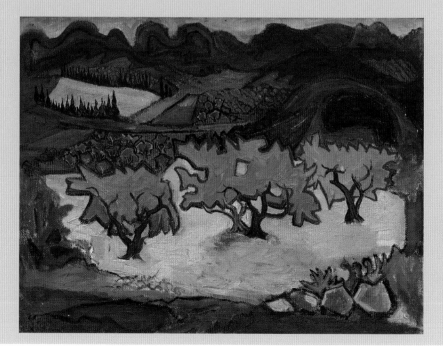

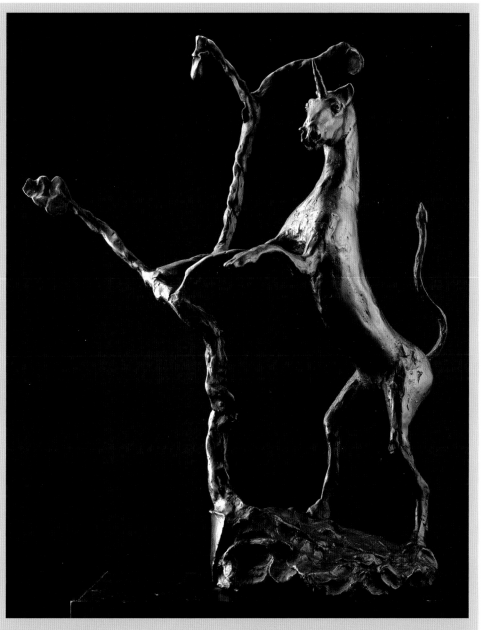

Barry Flanagan OBE RA
(1941–2009)
Unicorn and Oak Tree
Bronze
H 60 cm

Prof H. T. Cadbury-Brown
OBE RA (1913–2009)
Origins of Land Pavilion
for the 1951 Festival of Britain,
South Bank, London, 1948
Pen, ink and gouache
60 × 69 cm

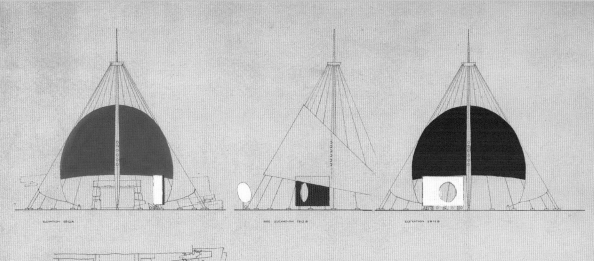

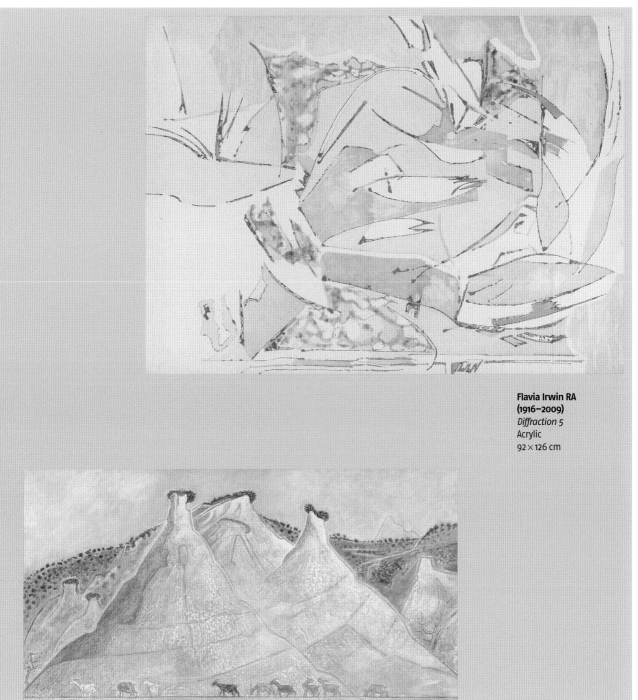

**Flavia Irwin RA
(1916–2009)**
Diffraction 5
Acrylic
92 × 126 cm

**John Craxton RA
(1922–2009)**
*Landscape, Kaloudiana,
c. 1984–85*
Acrylic tempera
60 × 110 cm

Frank Bowling OBE RA
Tent
Acrylic
84 × 126 cm

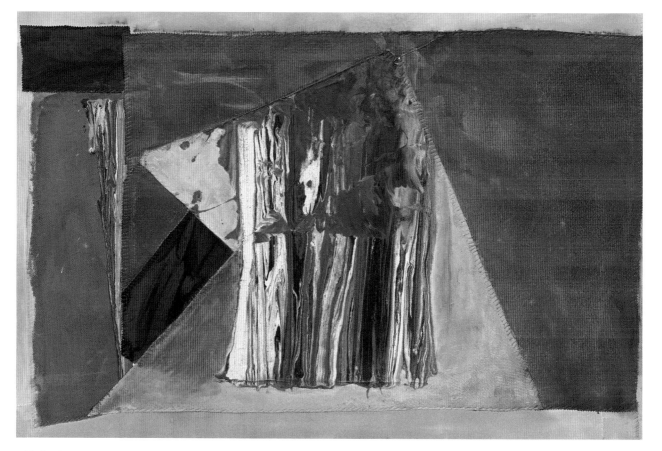

Joe Tilson RA

Finestra Veneziana San Marco Mixed media H 58 cm	*Finestra Veneziana San Luca* Mixed media H 58 cm	*Finestra Veneziana San Matteo* Mixed media H 58 cm	*Finestra Veneziana San Giovanni* Mixed media H 58 cm

Hew Locke
Dust to Dust No. 8
Mixed media
H 128 cm

Dr Barbara Rae CBE RA
Scar
Mixed media
198 × 214 cm

Anthony Whishaw RA
Celestial I 2007–10
Acrylic
167 × 229 cm

Prof William Alsop OBE RA
Brown Garden
Acrylic
180 × 200 cm

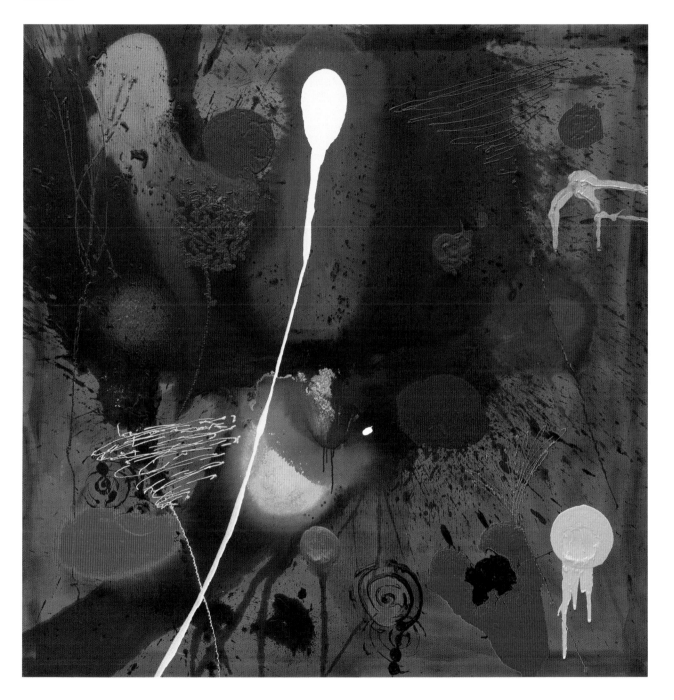

Prof Maurice Cockrill RA
We Three
Acrylic
180 × 150 cm

Albert Irvin RA
Fortune I, 2009
Acrylic
183 × 152 cm

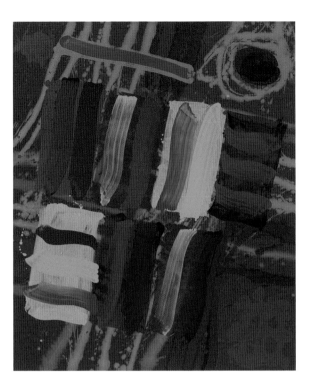

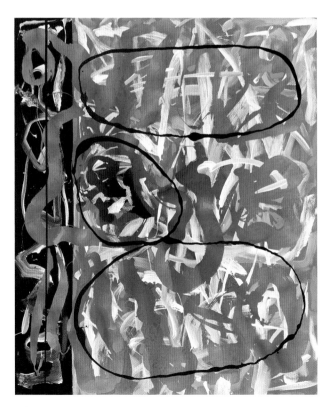

Jeffery Camp RA
Ralph
Oil
396 × 427 cm

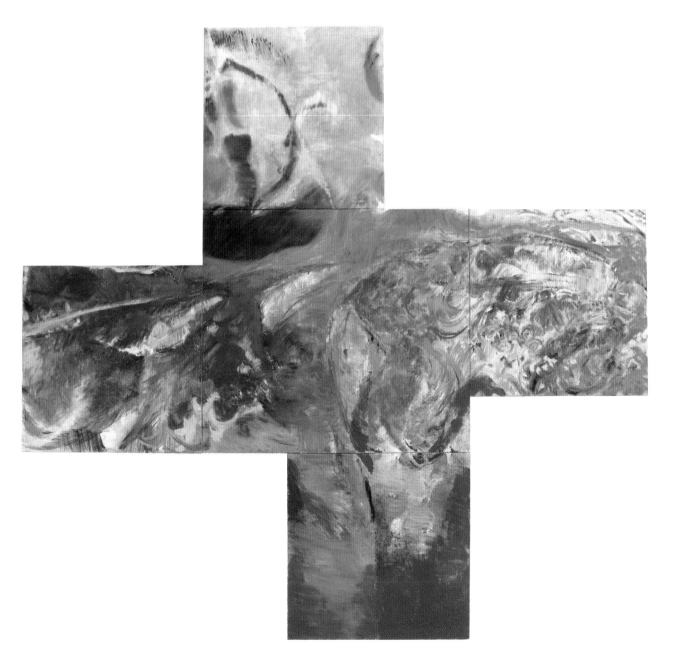

Terry Setch RA
Landfill
Mixed media
212 × 170 cm

Prof John Hoyland RA
Memories of Rain, 14–04–09
Acrylic
252 × 236 cm

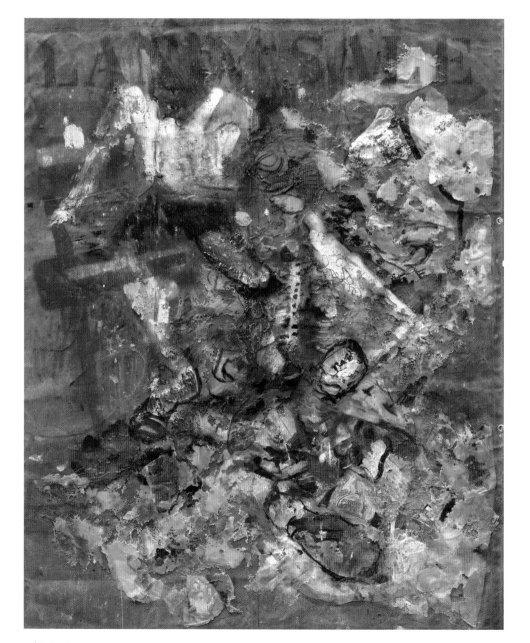

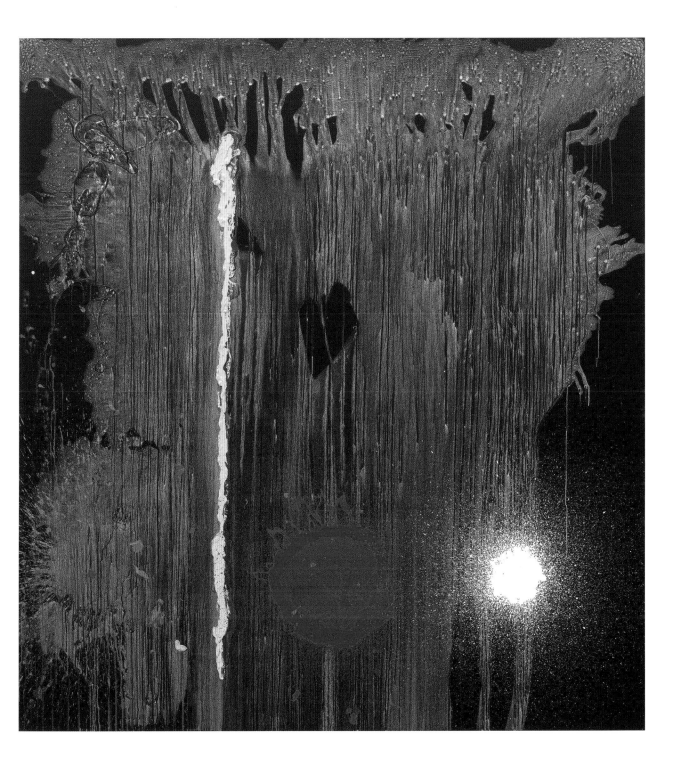

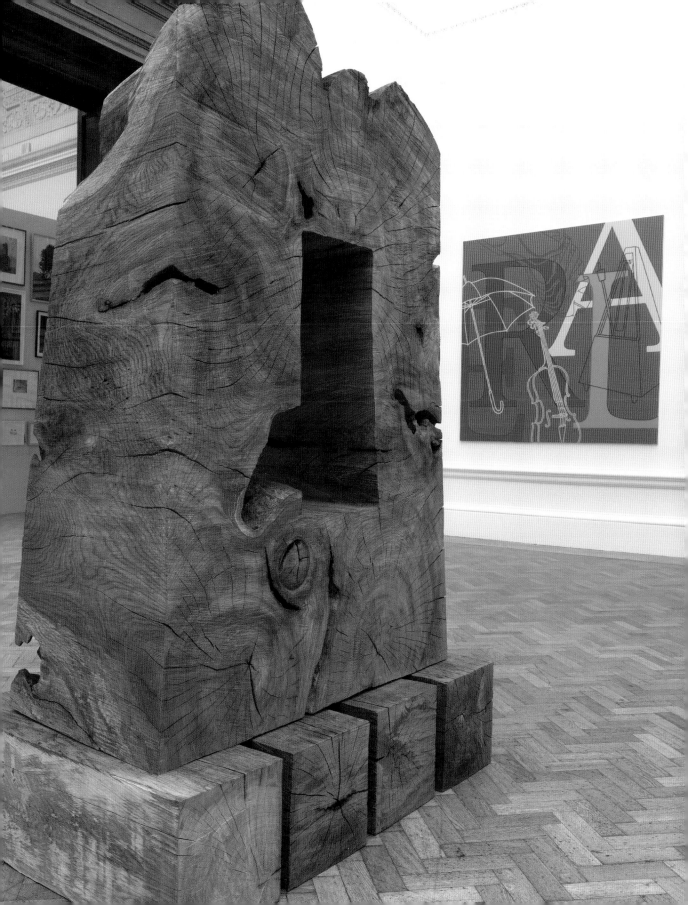

Sean Scully
Outside In (Yellow)
Oil on aluminium
183 × 305 cm

Hughie O'Donoghue RA
Sanguineto
Oil
246 × 214 cm

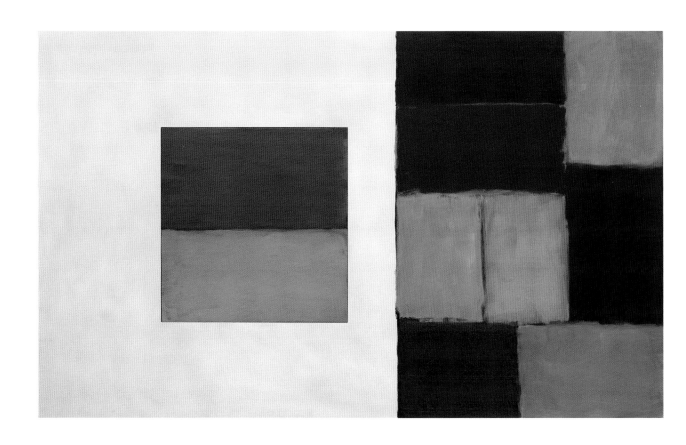

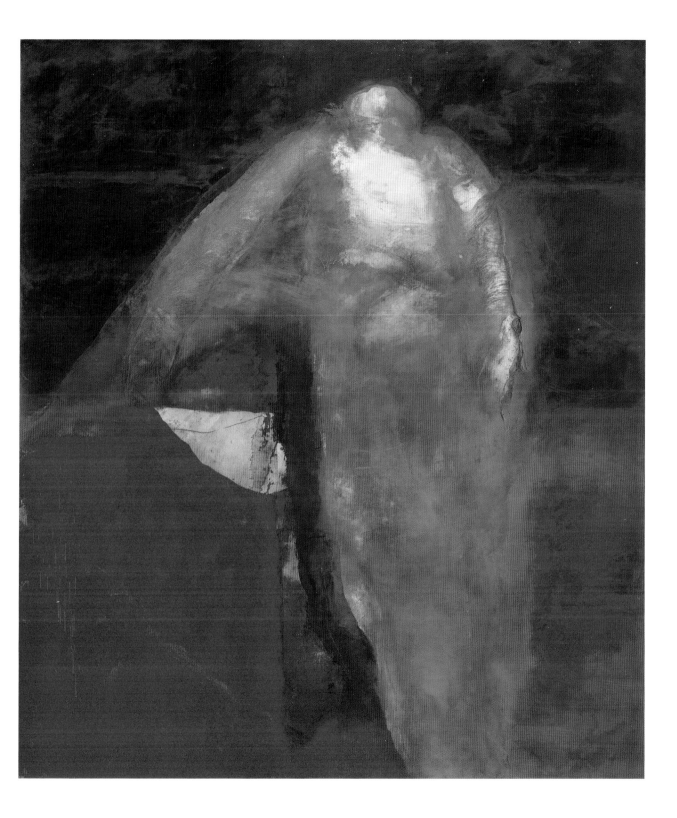

Richard Smith
High Fashion, 2000
Oil
180 × 180 cm

Matthew Collings and Emma Biggs
The Unseen
Oil
203 × 203 cm

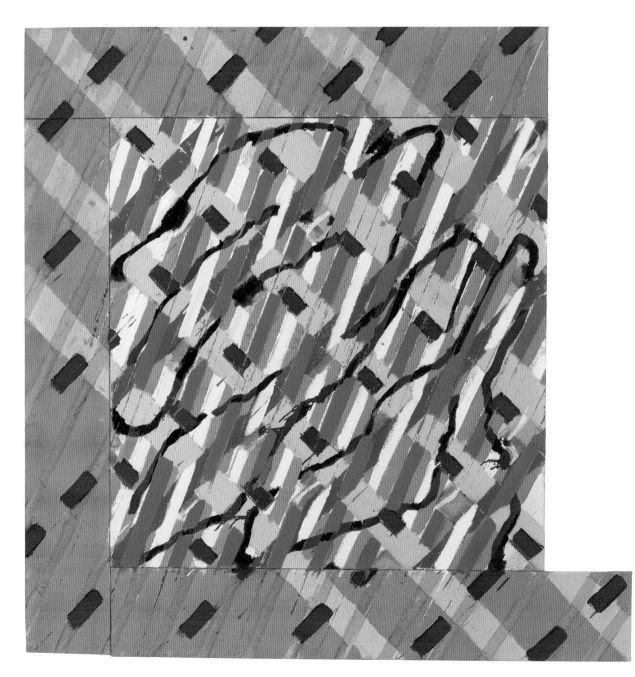

Grayson Perry
Personal Creation Myth
Glazed ceramic
H 49 cm

Jane Harris
Divine
Oil
193 × 290 cm

LARGE WESTON ROOM

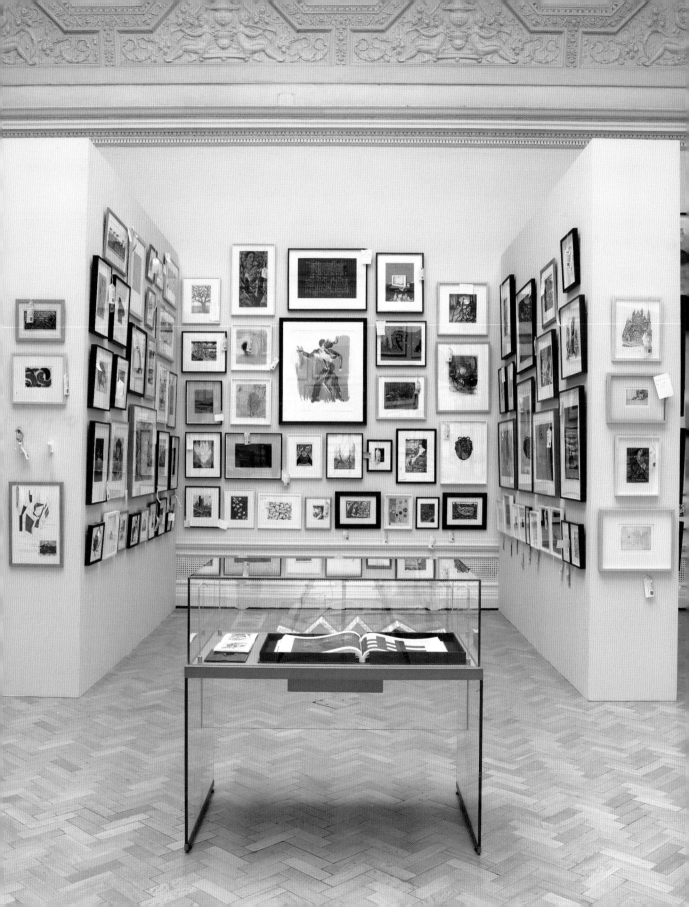

John Dilnot
Weeds and Pests
Screenprint
17 × 13 cm (folded)

Ron King
Woodworm Book (Logbook No. 10)
Ash
11 × 9 cm (folded)

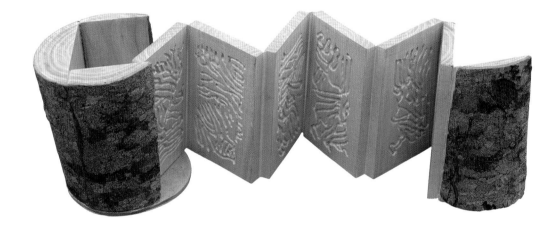

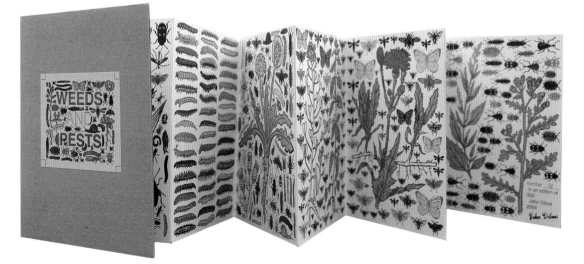

Ken Campbell
Pantheon
Letterpress print
13 × 40 cm

Les Bicknell
Translate Every Statement Into a Question
Book
14 × 13 cm

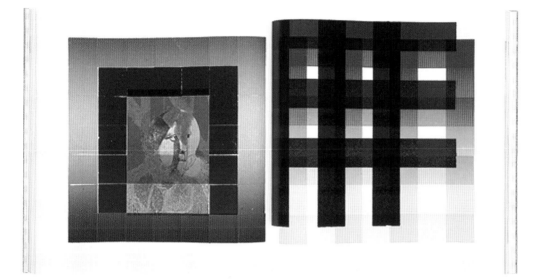

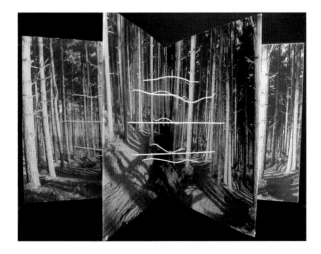

Michael Craig-Martin CBE RA
Kids
Screenprint
48 × 82 cm

Prof Chris Orr MBE RA
Film Noir in Colour. Times Square, New York
Lithograph
94 × 67 cm

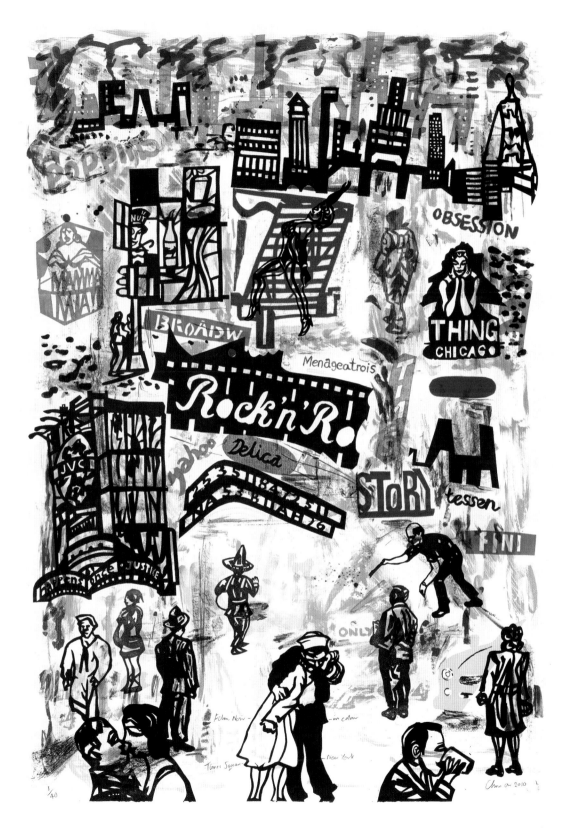

Sara Lee
Fable
Drypoint and *chine collé*
25 × 20 cm

Claas Gutsche
Suburbia
Linocut
45 × 35 cm

Bill Jacklin RA
Wollman Rink I
Inkjet print
50 × 48 cm

Danny Rolph
PW
Etching
39 × 60 cm

John McLean
Drumsturdy
Screenprint
75 × 85 cm

Paula Rego
Penetration
Etching and aquatint
30 × 40 cm

Lauren Drescher
Girl's Best Friend
Plasma cut–steel relief print
75 × 55 cm

Gary Hume RA
Bikini
Silkscreen
60 × 40 cm

Peter Freeth RA
Serenissima
Aquatint
17 × 20 cm

Christopher Le Brun RA
The Palace of Art
Etching
22 × 24 cm

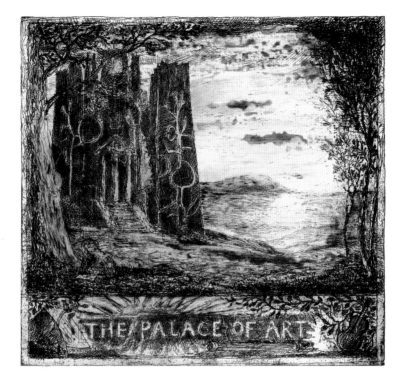

Eleanor Havsteen–Franklin
Flowing II
Etching
53 × 59 cm

Celia Paul
St George's Bloomsbury, Night
Etching
13 × 10 cm

Willard Boepple
W–7 2010
Etching
36 × 27 cm

John Carter RA
Six Identical Shapes 2010
Etching
38 × 38 cm

Louise Bourgeois
Ladders
Etching
30 × 25 cm

Prof Ivor Abrahams RA
Suburban Totem
Etching
157 × 71 cm

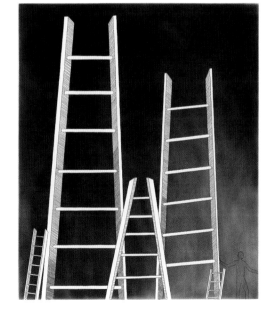

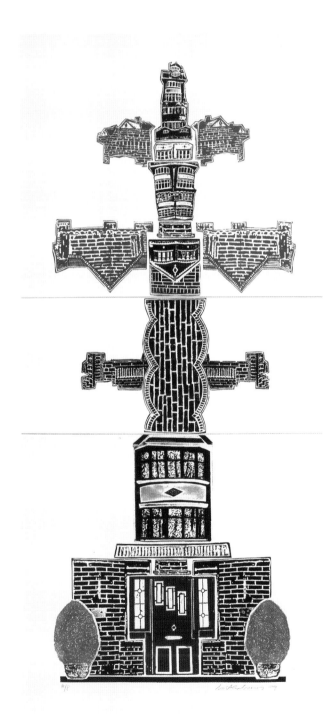

Ian Davenport
Etched Puddle No. 3
Etched monoprint
70 × 52 cm

Bronwen Sleigh
Fliedersteg
Hand-coloured etching
59 × 48 cm

GW Bot
Paddock Glyphs – Lost Path 2008
Linocut
70 × 99 cm

Thomas Williams
Out Side In Side Out
Wood engraving
16 × 16 cm

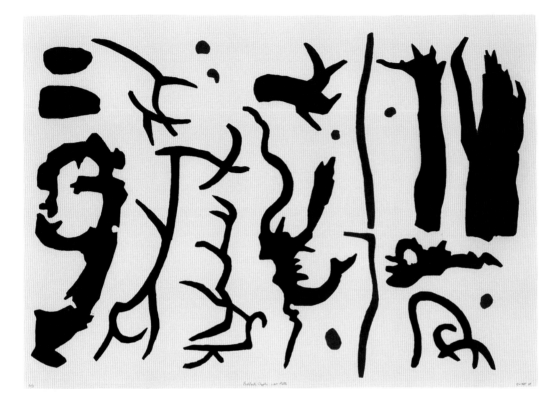

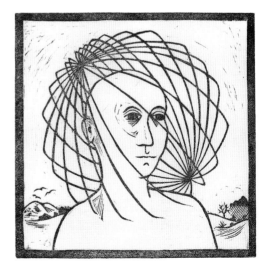

Frank Auerbach
Bill
Etching
18 × 15 cm

Sir Nicholas Grimshaw CBE PRA
Estuary III
Etching
26 × 34 cm

Dr Jennifer Dickson RA
Morning Radiance, Isola Bella
Inkjet and watercolour print
26 × 39 cm

Eileen Hogan
Bryanston Square
Etching
34 × 34 cm

Katsutoshi Yuasa
One Hundred Million Years of Solitude #3
Woodcut
105 × 75 cm

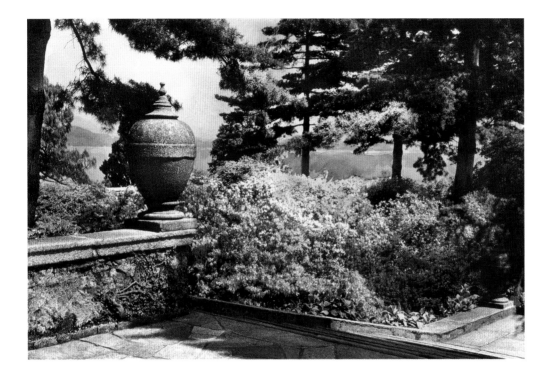

Richard Kirwan
False Fire
Screenprint and etching
59 × 42 cm

Peter Donaldson
Amuse – Bouche
Digital print
19 × 15 cm

Mark Hampson
Bricabrac (This and That)
Lithograph and silkscreen
57 × 44 cm

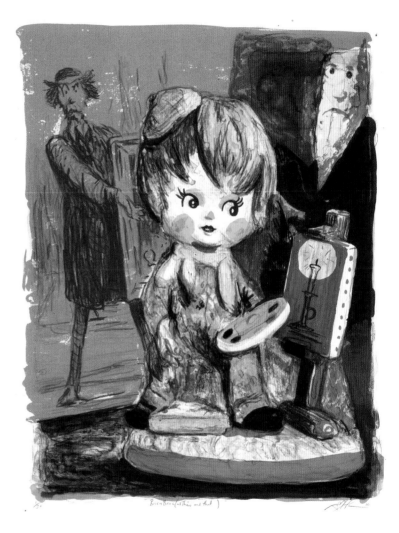

SMALL
WESTON
ROOM

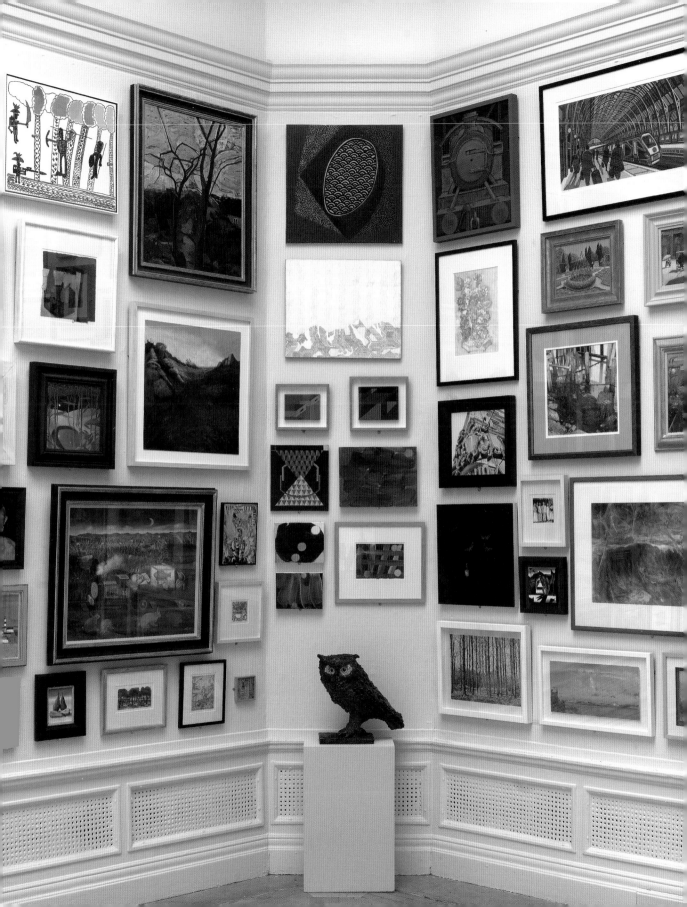

Kate Montgomery
Sitter
Casein
38 × 30 cm

Marguerite Horner
In the Middle of Nowhere
Oil
50 × 50 cm

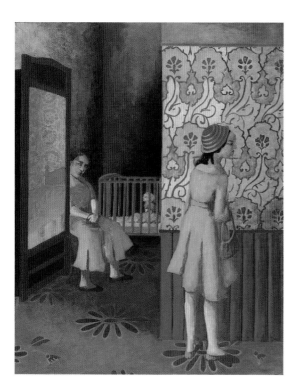

Gus Cummins RA
Manchuria
Acrylic
53 × 75 cm

James Martelli
Road Sign
Enamel on road sign
45 × 60 cm

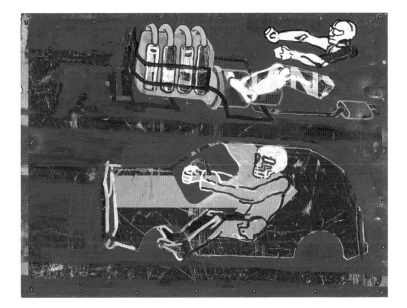

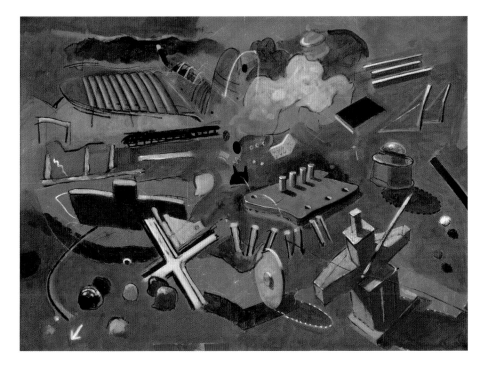

Rachel Clark
South Bank
Pastel
29 × 39 cm

Sonia Lawson RA
Up the Garden Path
Oil and pigment
21 × 29 cm

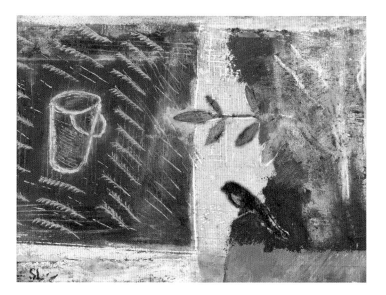

Maria Högbacke
Five Degrees of Separation
Oil
60 × 50 cm

Christopher Wood
Woodland Queen – Titania
Oil
91 × 96 cm

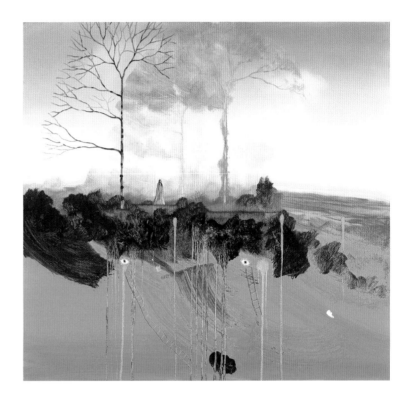

Melanie Miller
Starling
Oil
50 × 52 cm

Jeffrey Dennis
Jack of the Crossing
Oil and charcoal
21 × 25 cm

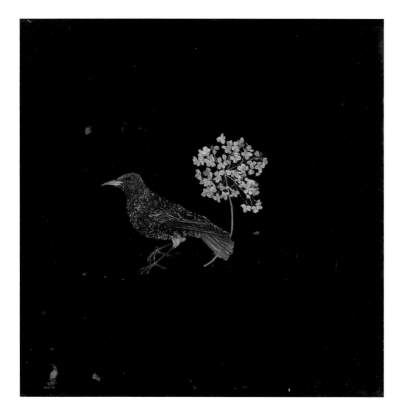

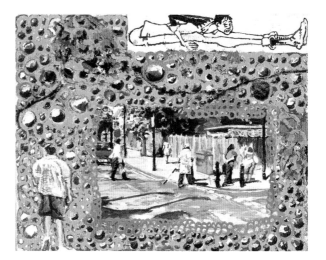

Dame Elizabeth Blackadder DBE RA
Peruvian Gloves and Exotic Fruit
Oil
39 × 44 cm

Oliver McConnie
Invocation
Etching
17 × 15 cm

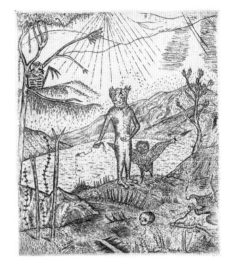

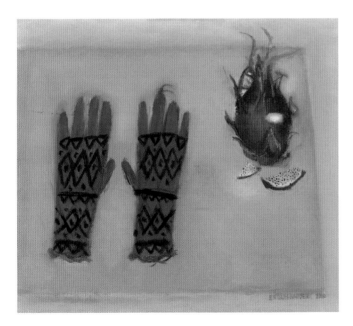

Leonard Rosoman OBE RA
The QE : The Deck Structure
Gouache
45 × 53 cm

Diana Armfield RA
Roses on the Kitchen Table
Oil
29 × 34 cm

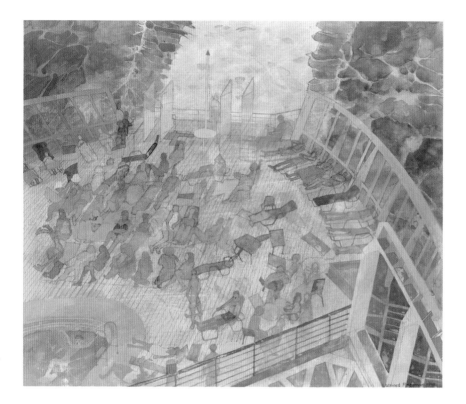

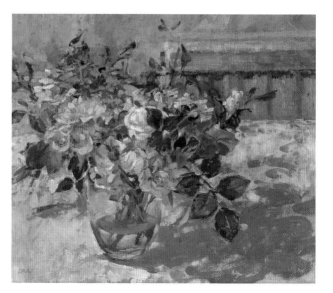

Mick Rooney RA
Girl Dreaming, Pizza Drifting
Oil
58 × 74 cm

Bernard Dunstan RA
Sitting by the Window
Oil
28 × 27 cm

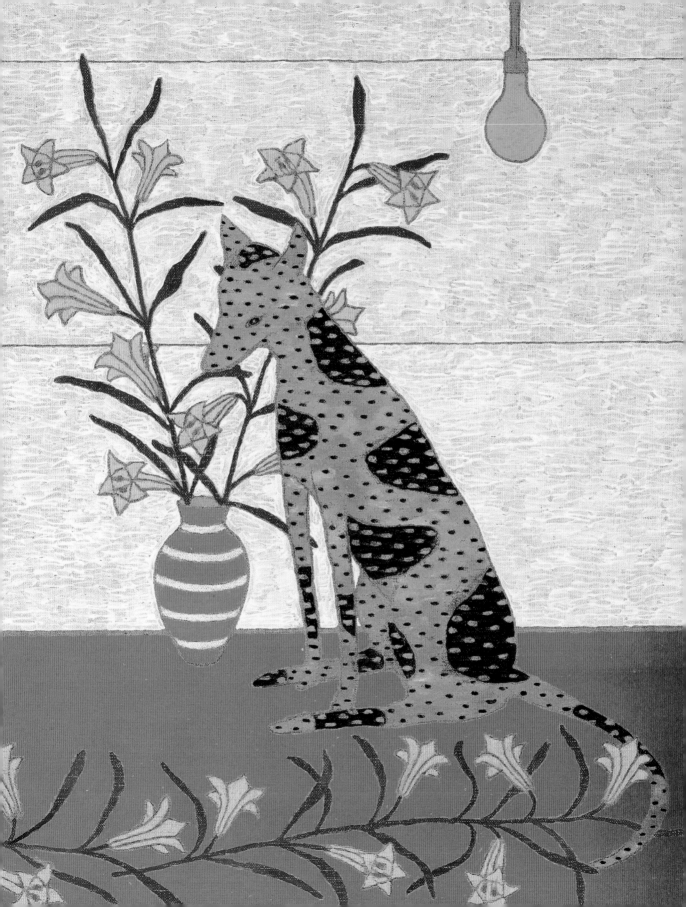

Georg Baselitz Hon RA
Mittendrin
Oil
272 × 202 cm

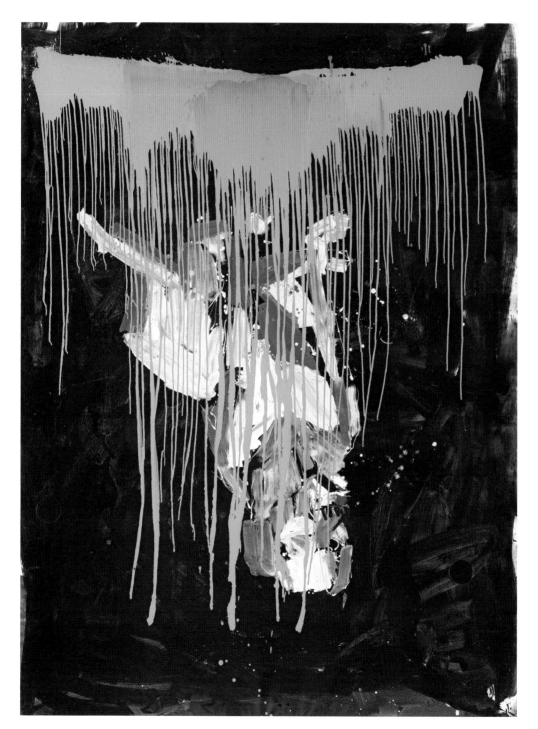

Humphrey Ocean RA
Kate
Gouache
76 × 56 cm

Humphrey Ocean RA
Geoffrey
Gouache
76 × 56 cm

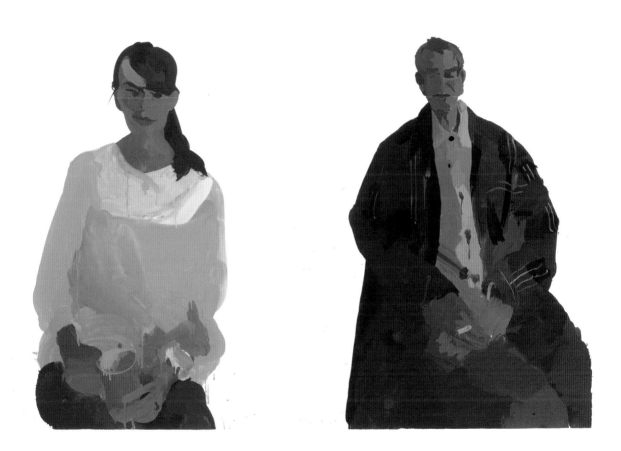

Henry Mundy
Untitled
Acrylic
121 × 283 cm

Gillian Ayres OBE RA
High Summer World of Light
Oil
199 × 275 cm

Stephen Chambers RA
Beam/Boat/Boy/Branch
Oil
160 × 200 cm

Prof Stephen Farthing RA
Abacus
Acrylic
207 × 173 cm

James Fisher
You Won't Hear My Step
Oil
138 × 152 cm

Christopher Appleby
Inspector Dee Spied a Fairee Queene
Mixed media
76 × 91 cm

Andrzej Jackowski
Figure with Small Garden
Oil
143 × 183 cm

Mick Moon RA
Tree
Mixed media
61 × 61 cm

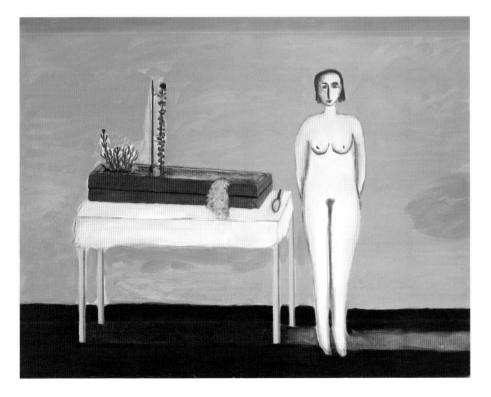

Tony Bevan RA
Self-portrait after Messerschmidt
Acrylic and charcoal
268 × 247 cm

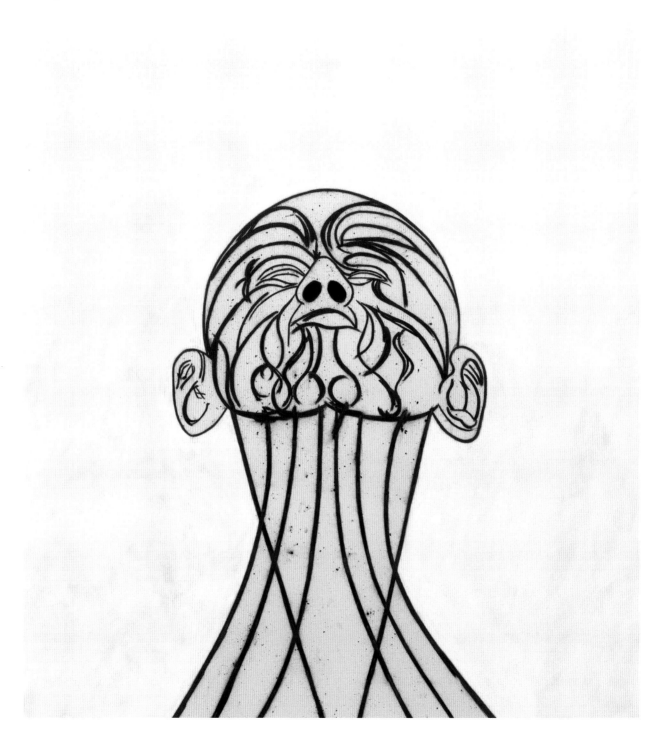

Basil Beattie RA
Far and Away (Janus Series) 2010
Oil and wax
213 × 198 cm

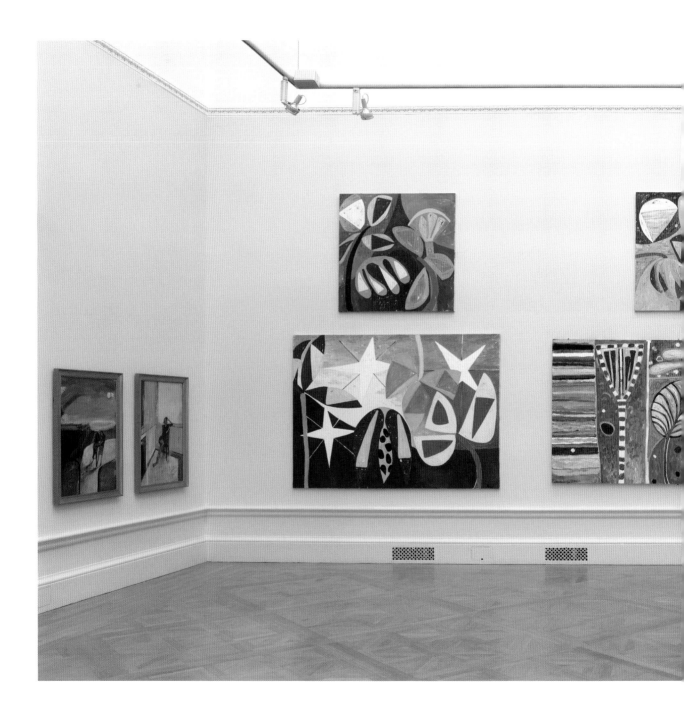

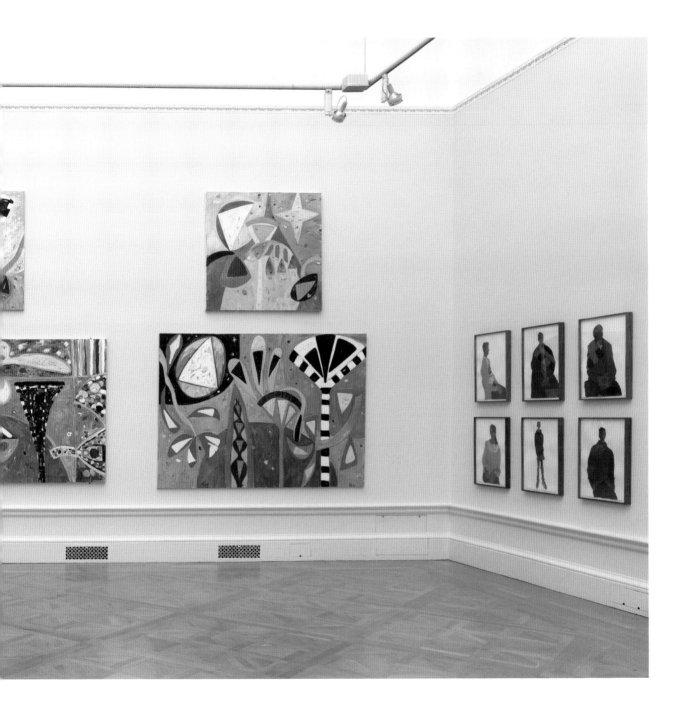

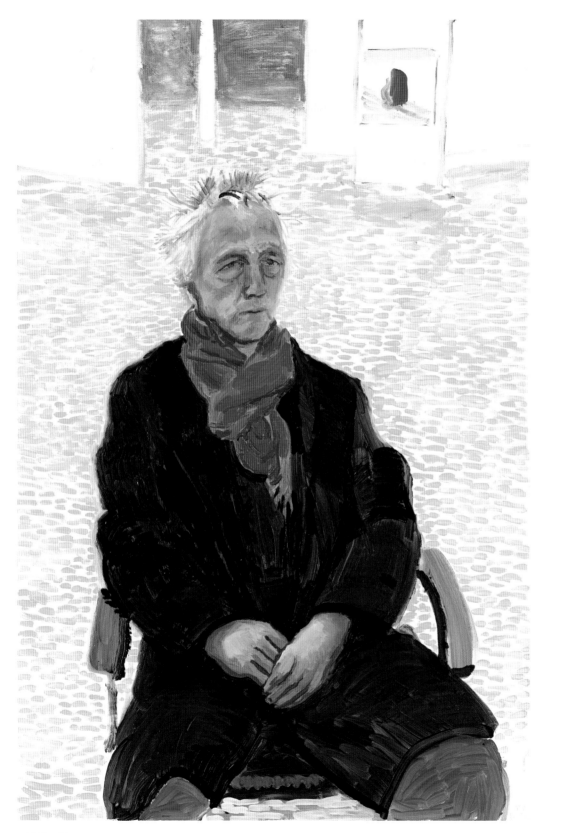

David Hockney CH RA
Maurice Payne, March 2010
Oil
130 × 86 cm

John Wragg RA
The Red Dress
Acrylic
120 × 83 cm

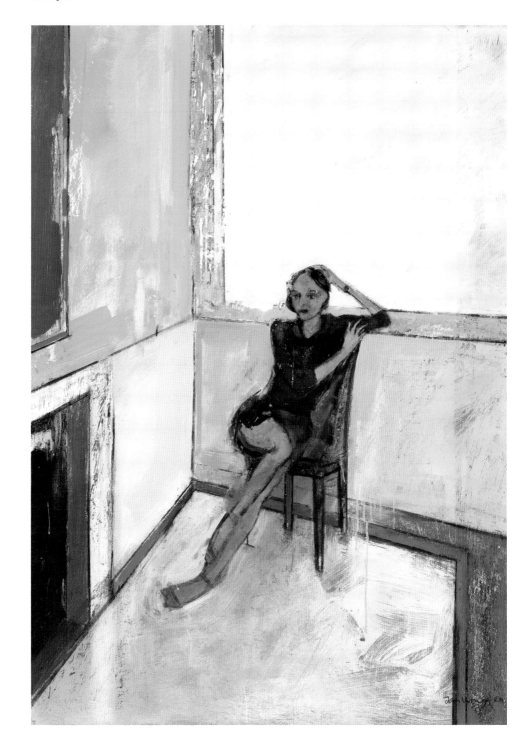

Ross Bleckner
Time (Mechanism)
Oil
184 × 184 cm

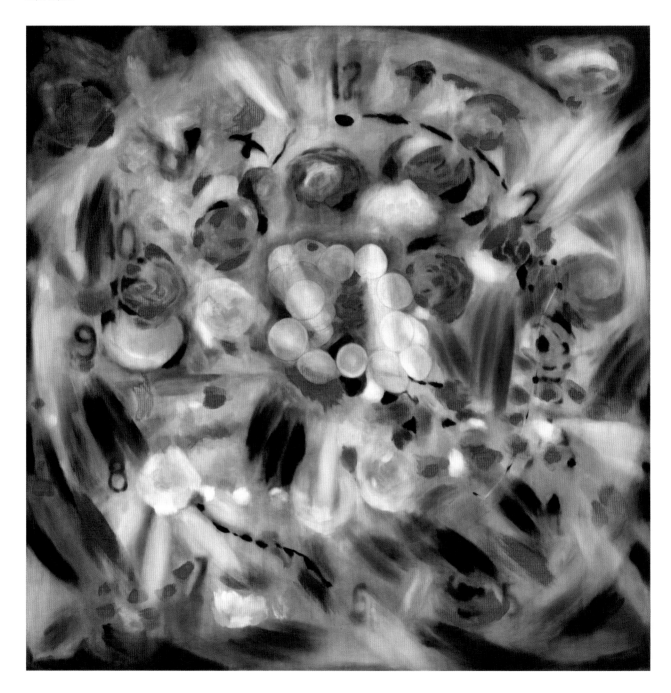

Mimmo Paladino Hon RA
Terra
Mixed media
160 × 180 cm

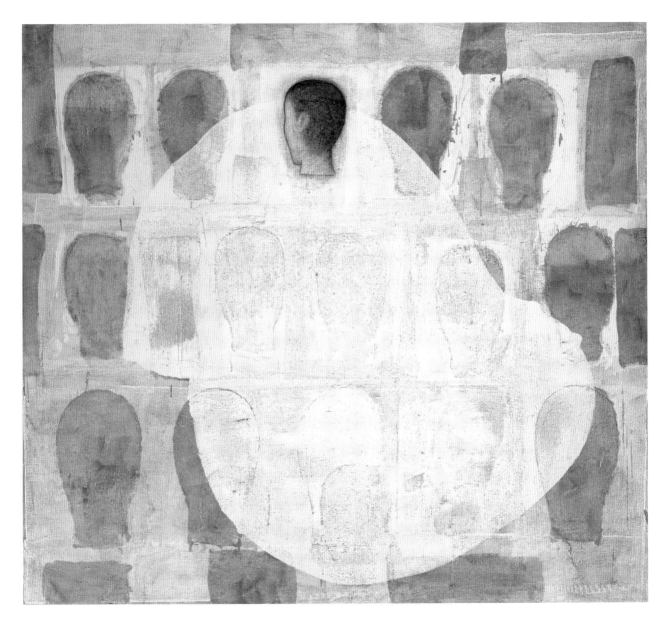

Tom Phillips CBE RA
Rilke's Angels
Oil
74 × 89 cm

Nancy Spero
Carnival
Collage
250 × 51 cm

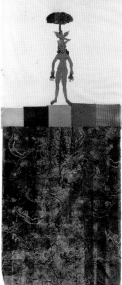

Elizabeth Magill
Blue Hold
Oil
153 × 183 cm

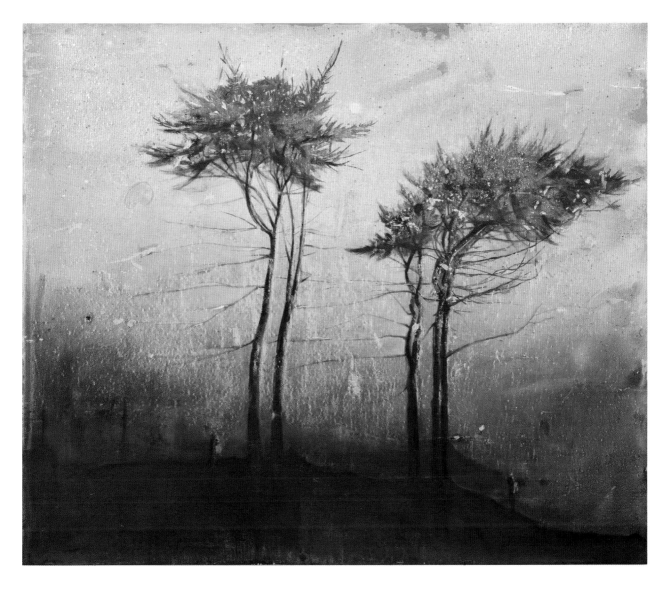

Ed Ruscha Hon RA
King's Highway
Acrylic
92 × 122 cm

Tal R
Minus Yesterday, Minus Tomorrow
Oil
250 × 250 cm

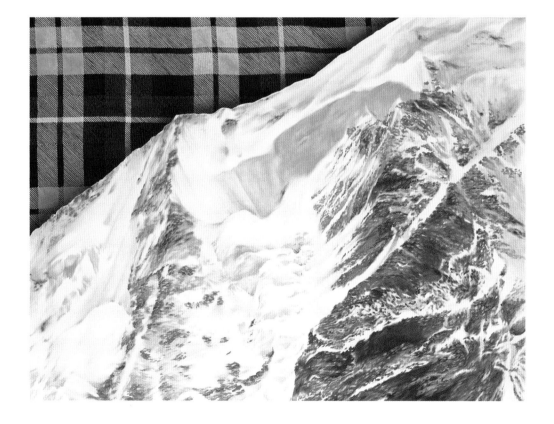

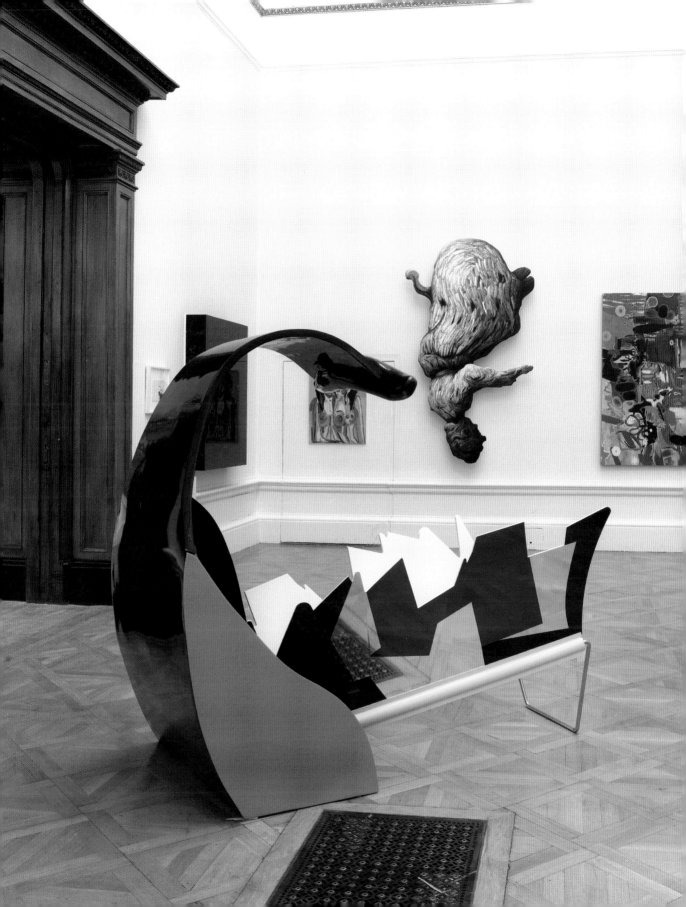

Nigel Cooke
In Da Club – Me Time 2010
Oil
220 × 195 cm

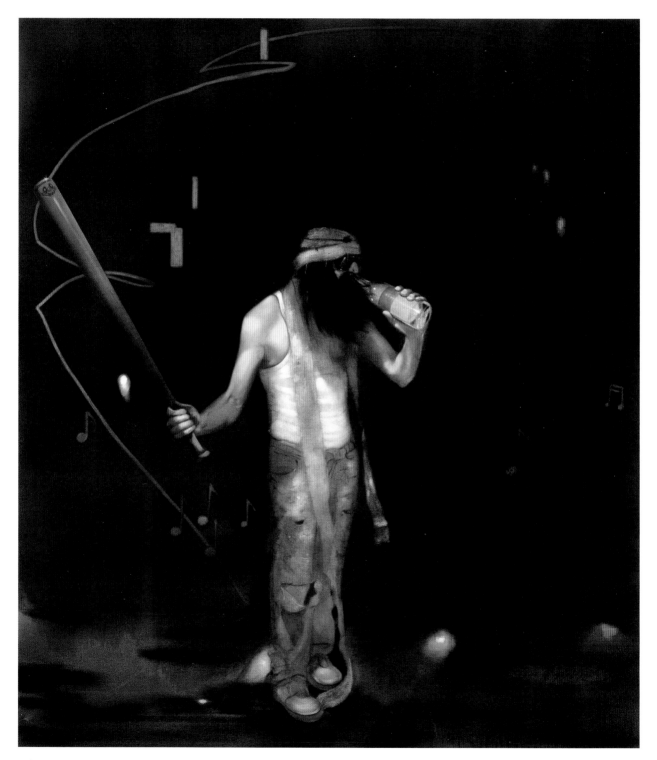

Martin Maloney
International Superstar
Oil
82 × 66 cm

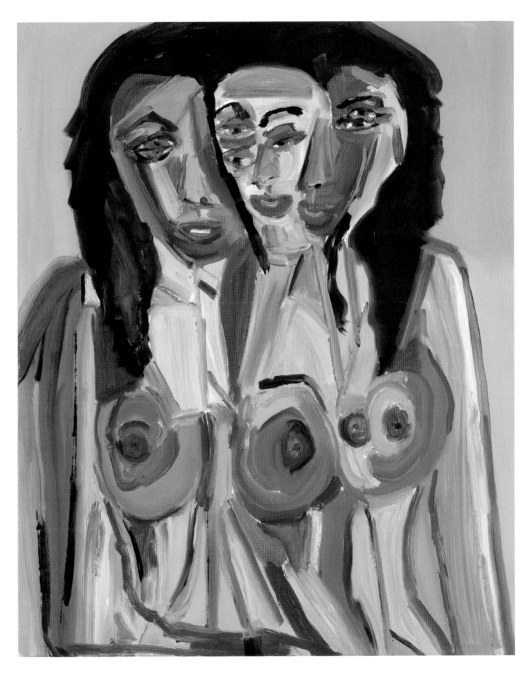

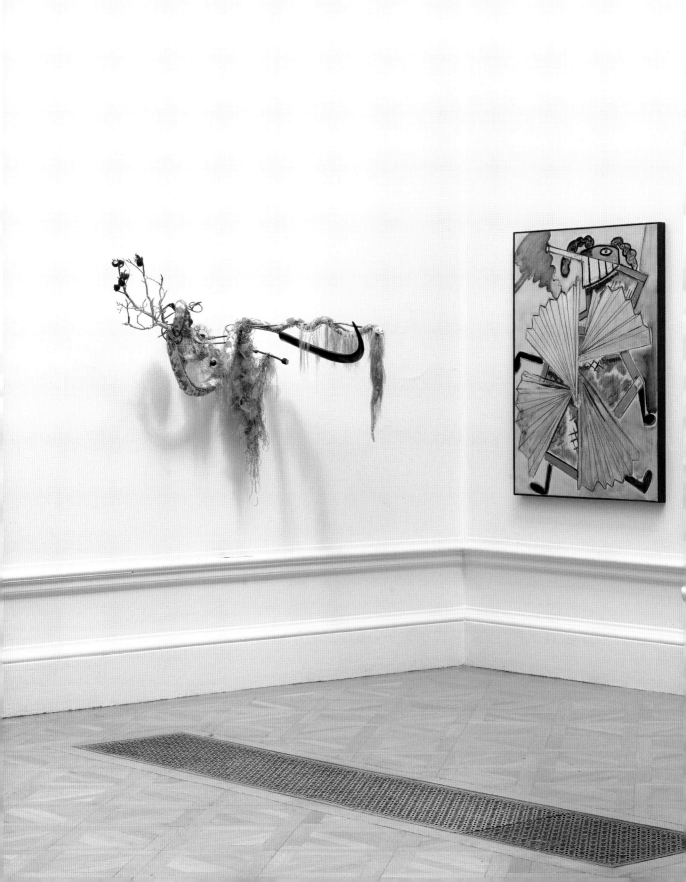

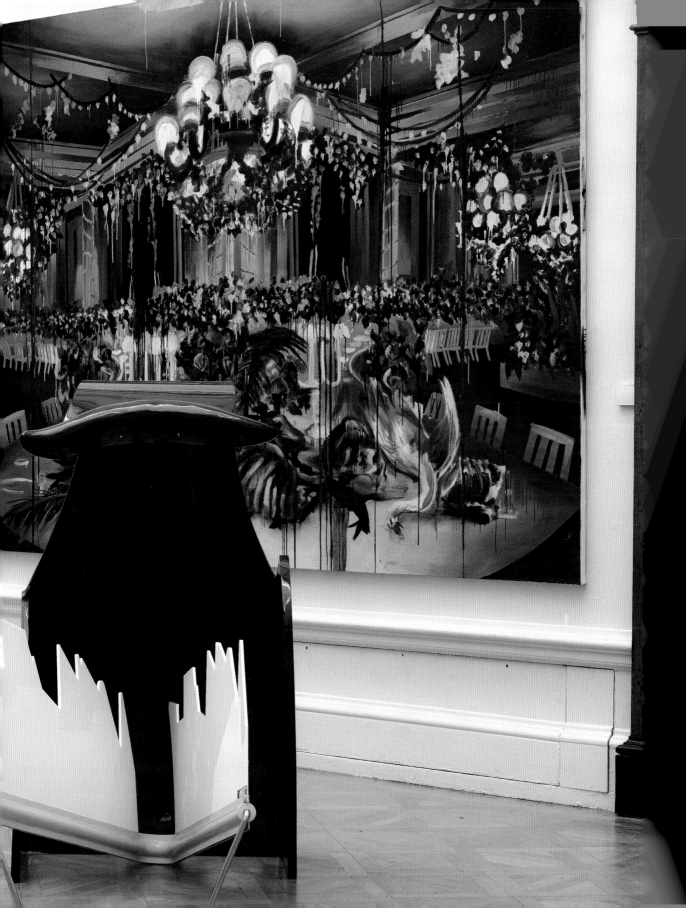

Frank Nitsche
DSY–19–2009
Oil
220 × 200 cm

Ansel Krut
Exotic Dancer
Oil
50 × 120 cm

Hiroe Saeki
Untitled
Pencil
8 × 24 cm

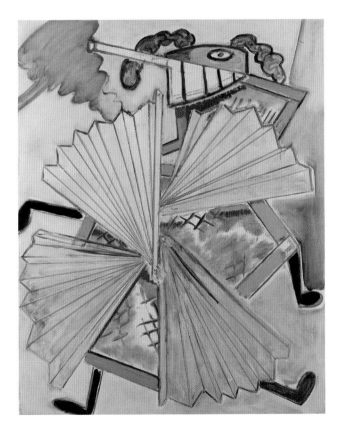

Prof Phillip King CBE PPRA
Monument to the Worm
Steel, plastic and slate
H 41 cm

Dan Perfect
Sandstorm
Oil and acrylic
183 × 257 cm

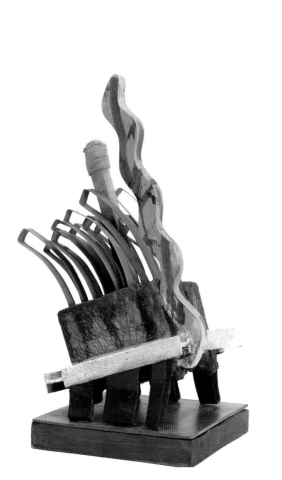

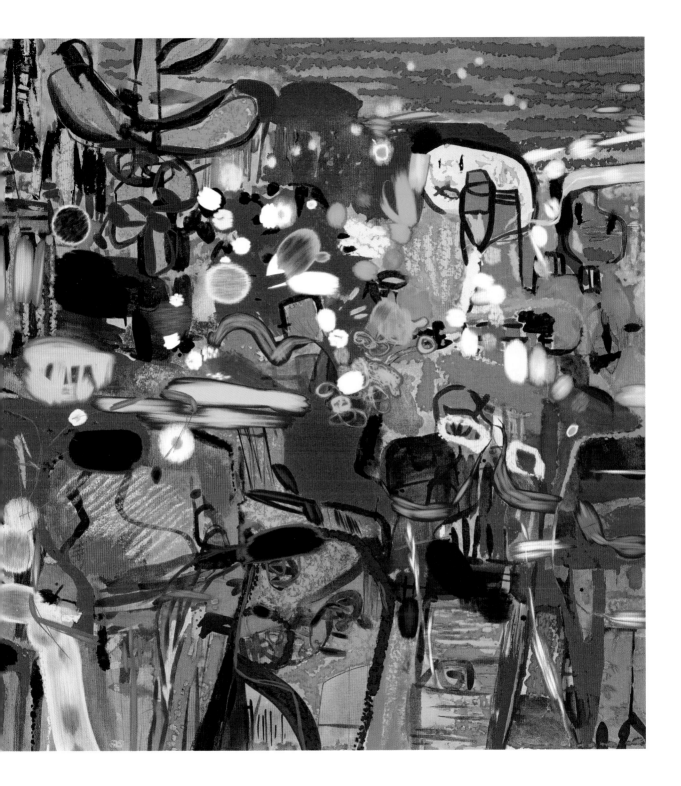

Cecily Brown
Don't Wake Me Up
Oil
109 × 79 cm

Cecily Brown
The Boy with a Thorn in His Side
Oil
109 × 79 cm

Fiona Rae RA
I Wish to Fully Grow My Small Dream
Oil, acrylic and gouache
152 × 127 cm

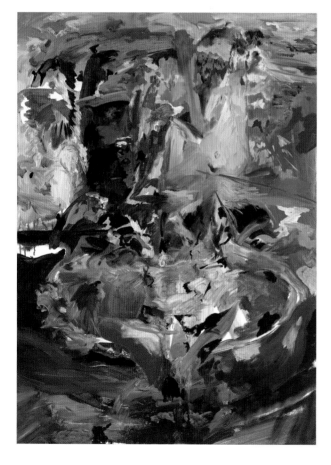

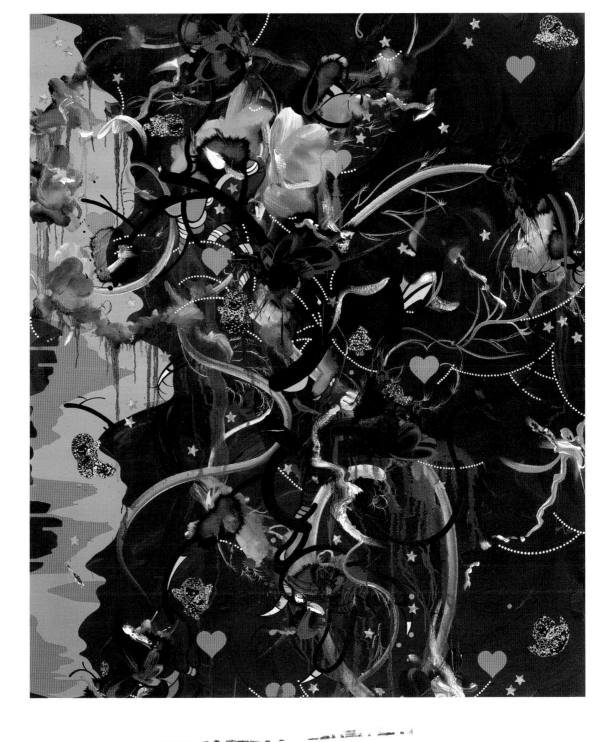

Nicola Tyson
Running Figure
Oil
193 × 153 cm

Glenn Brown
Song to the Siren
Oil
244 × 146 cm

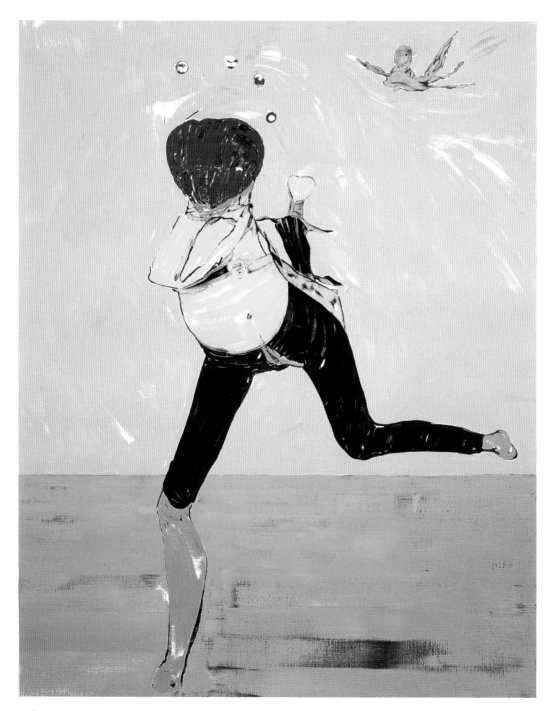

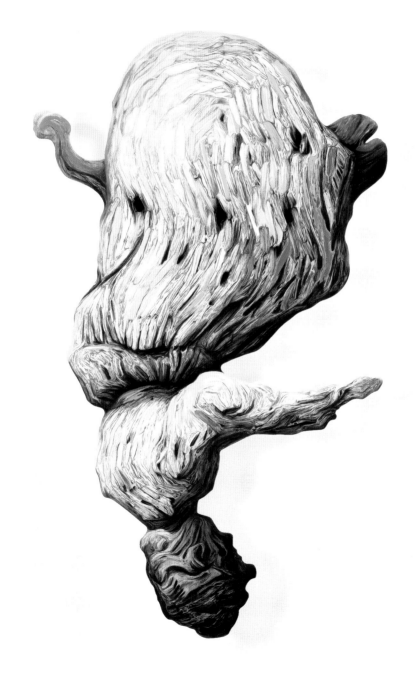

Richard Wilson RA
Shack Stack
Polyurethane resin
H 60 cm

John Carter RA
Forms Within a Frame, Large Version, 2010
Mixed media
H 102 cm

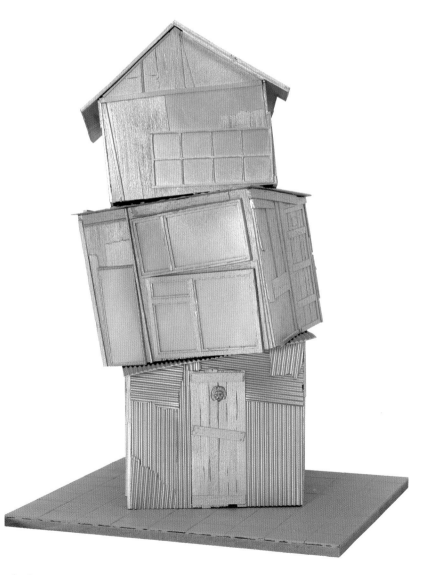

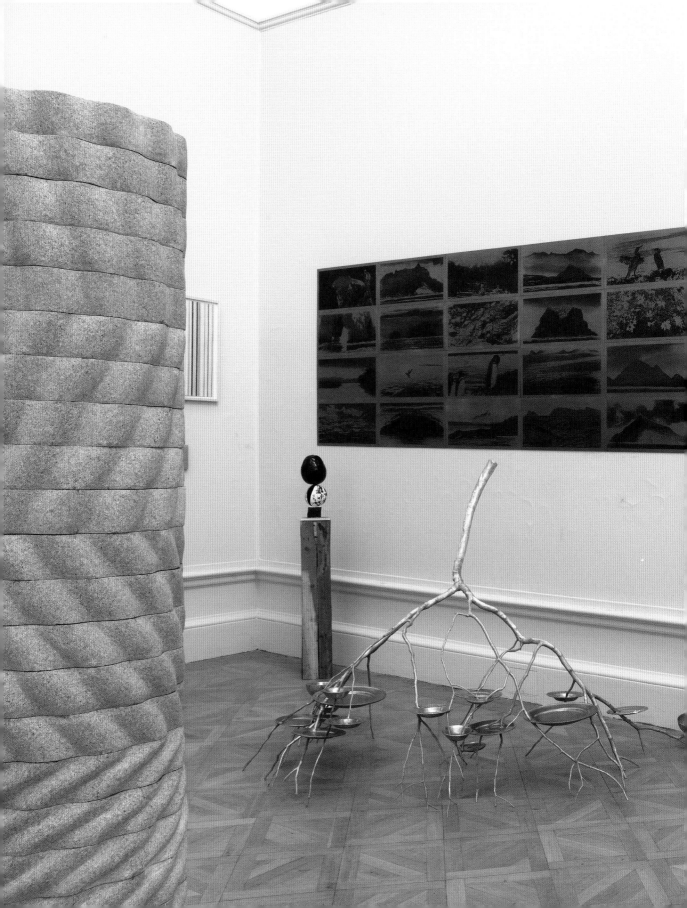

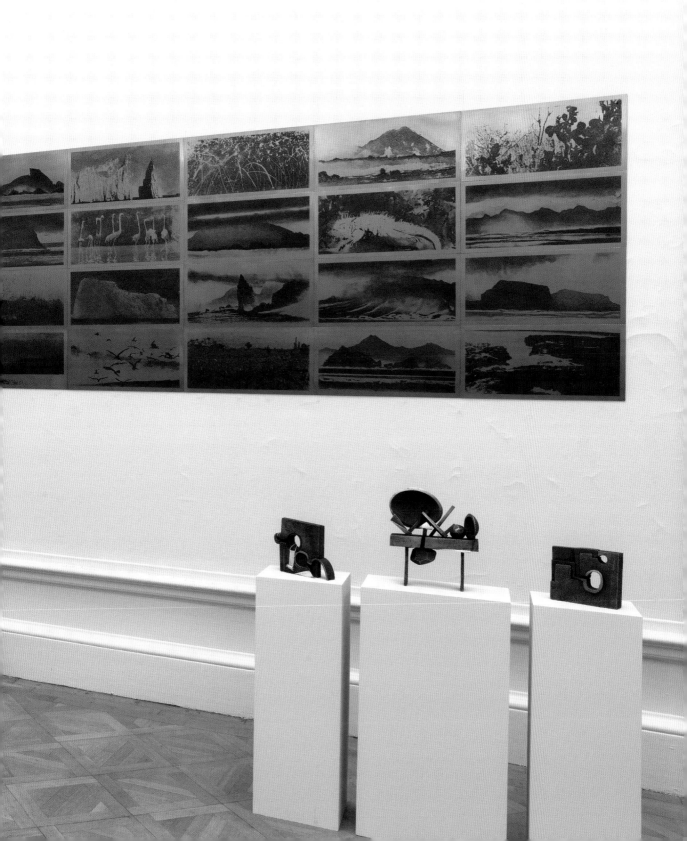

Sir Anthony Caro OM CBE RA
Reclining Nude, 2009
Charcoal
57 × 75 cm

James Butler MBE RA
Homage to Jean Sibelius
Bronze
H 57 cm

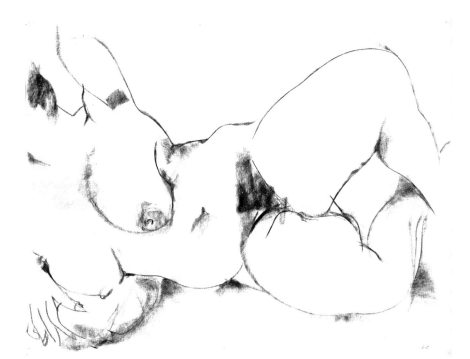

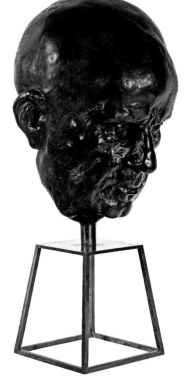

Trevor Sutton
The Anraku–Ji Temple, No. 2, 2009
Oil and paper
112 × 74 cm

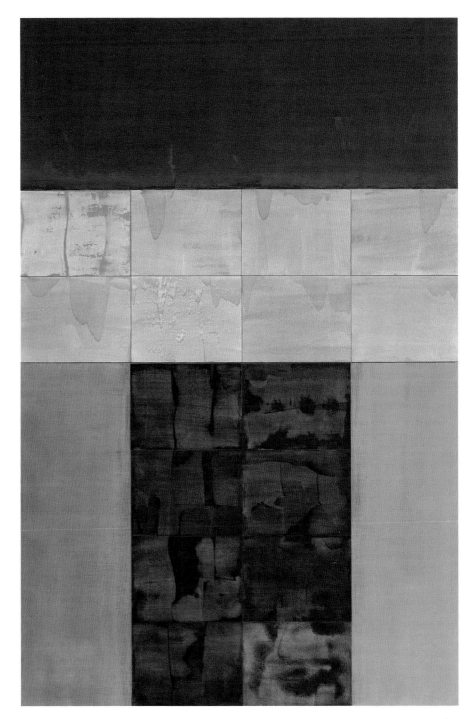

Tacita Dean RA
Study for Großsteingrab (Floating)
Mixed media
23 × 44 cm

Study for Riesenbett II (Floating)
Mixed media
23 × 44 cm

Study for Hünengrab II (Floating)
Mixed media
23 × 44 cm

Ann Christopher RA
Marks on the Edge of Space – 2
Mixed media
35 × 34 cm

Sarah Lucas
John
Bronze
H 16 cm

Cornelia Parker RA
The Fourth Estate, Reggie Kray's Funeral 11 October 2000
C–type prints
Each 31 × 44 cm

Tim Lewis
Book, 2010
Metal and wood
H 27 cm

Nigel Hall RA
Drawing 1529
Gouache and charcoal
120 × 306 cm

Alison Wilding RA
Ruff
Mixed media
H 73 cm

Prof Bryan Kneale RA
Mars
Bronze and brass
H 53 cm

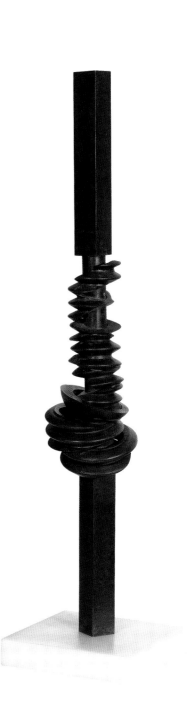

John Maine RA
Strata
Indian granite
H 250 cm

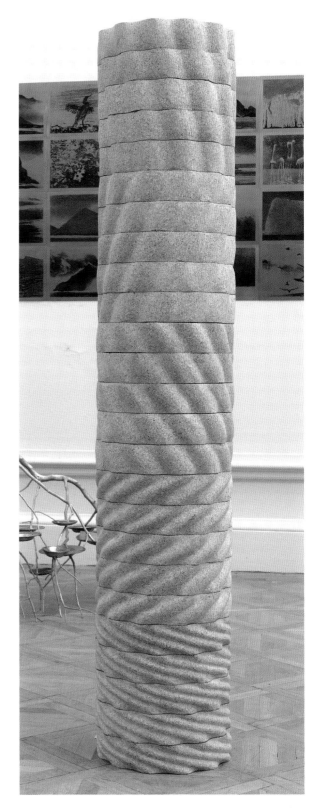

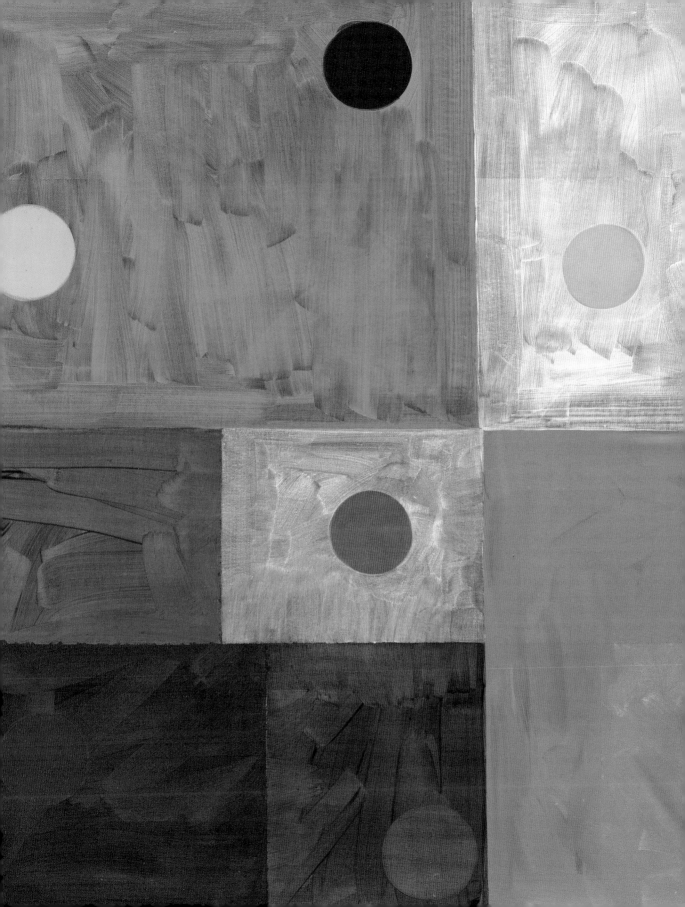

Adrian Berg RA
Enter the Garden
Oil
91 × 244 cm

Dan Rizzie
Four Holes of Water
Mixed media
71 × 64 cm

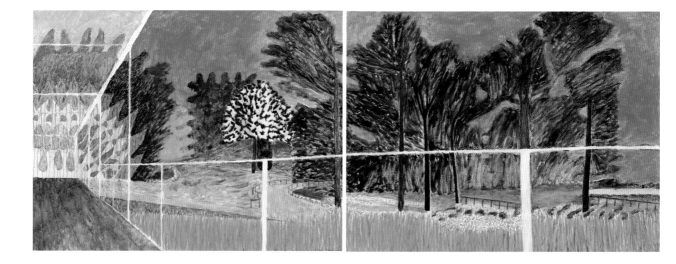

Olwyn Bowey RA
Making the Most of Bamboo
Oil
119 × 90 cm

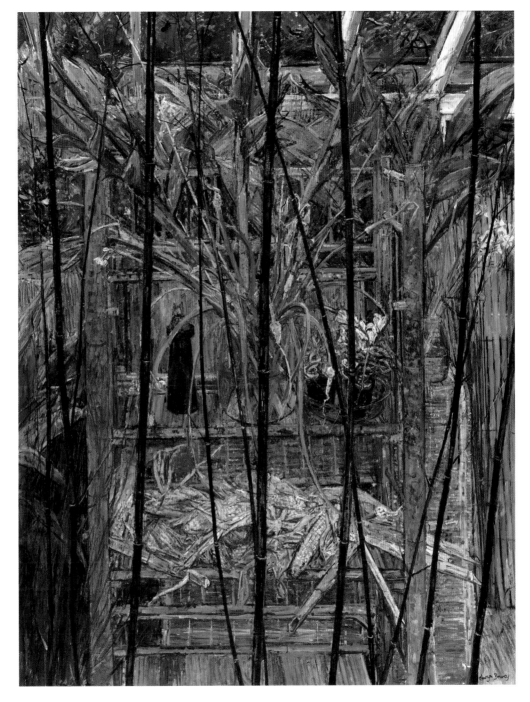

Prof Paul Huxley RA
Proteus VI
Acrylic
48 × 45 cm

Mali Morris RA
Flotilla
Acrylic
170 × 188 cm

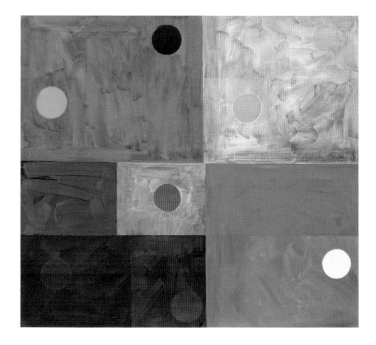

Callum Innes
Untitled No. 39
Oil
222 × 220 cm

Vanessa Jackson
Way Up
Oil
214 × 174 cm

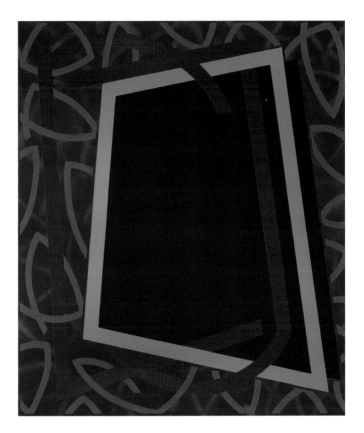

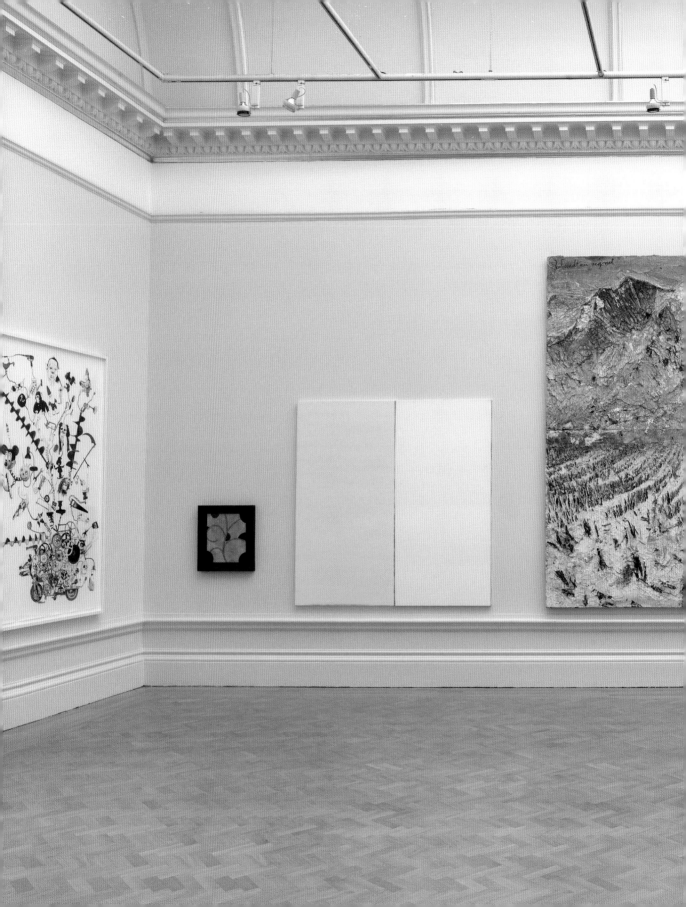

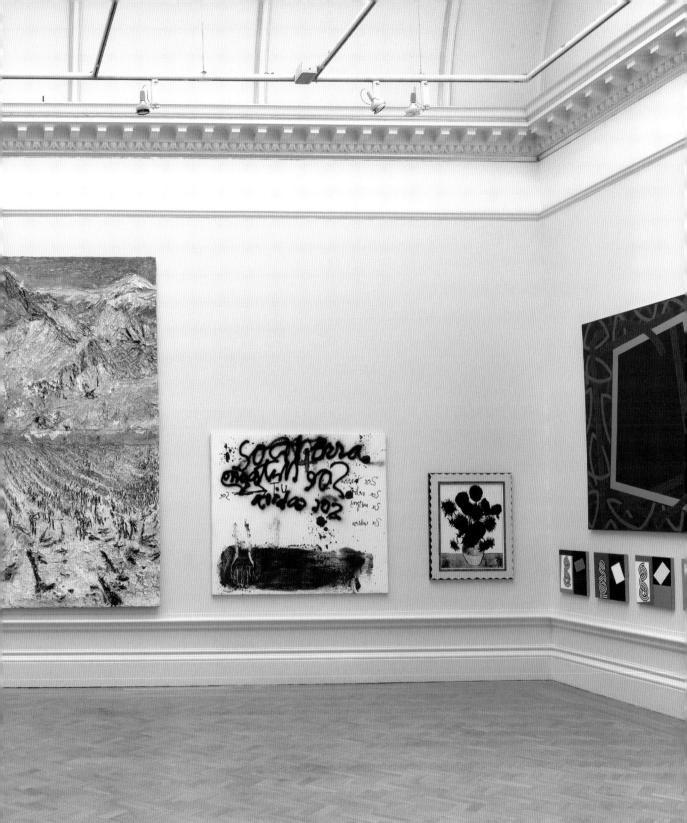

Antoni Tàpies Hon RA
Sóc Terra/I Am Earth
Mixed media
175 × 200 cm

Michael Landy RA
H.2.N.Y. Machine to Destroy Tinguely Museum (2), 2010
Charcoal
254 × 150 cm

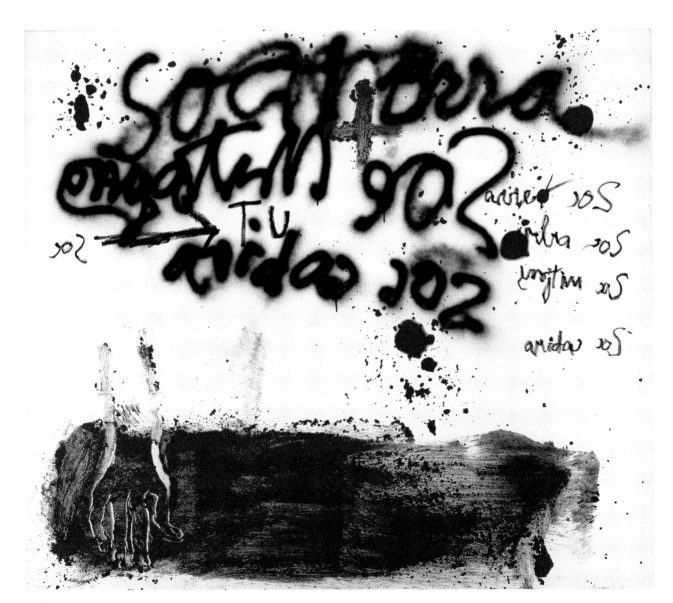

Dr John Bellany CBE RA
Sickert Strode These Streets, Dieppe
Oil
151 × 151 cm

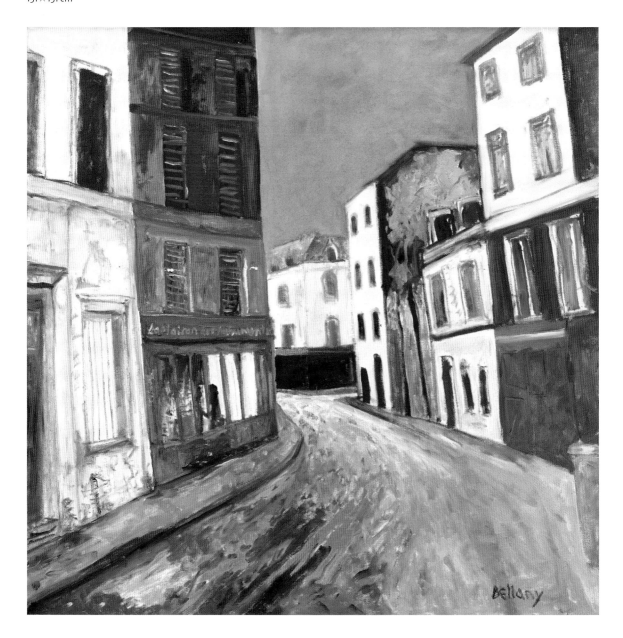

Rosa Loy
Der Planetenladen (The Planet Shop)
Casein
240 × 210 cm

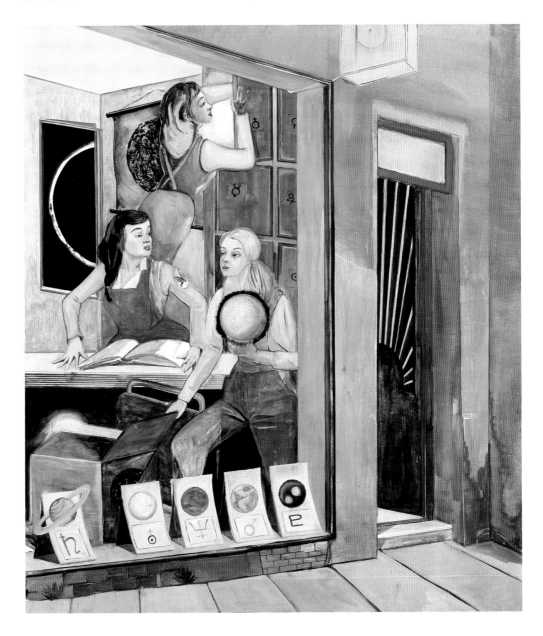

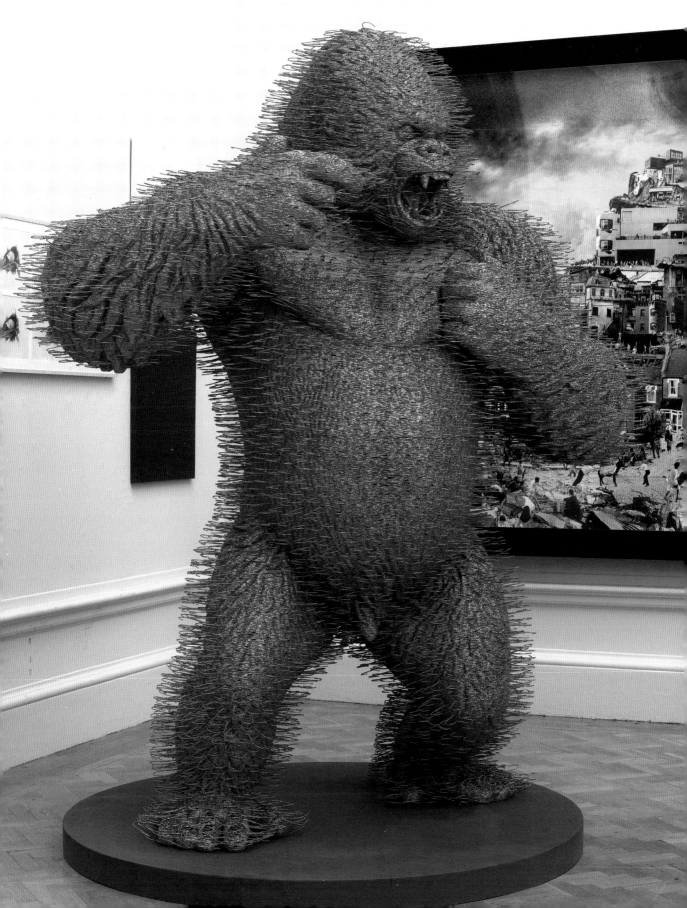

Carol Robertson
The Aviator, 2009
Oil
102 × 102 cm

Tess Jaray RA
Wolf. Green Pink
Mixed media
161 × 70 cm

Prof Michael Sandle RA
Siberian Fantasy
Watercolour
72 × 54 cm

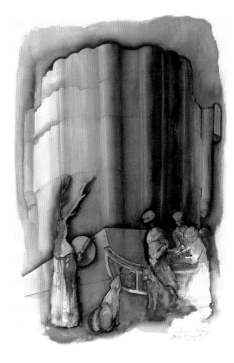

Geoffrey Clarke RA
Conflict of Interest
Cast aluminium
H 22 cm

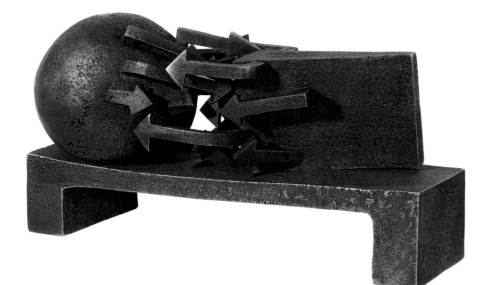

Tom Price
Corrance Road and Ducie Street
Bronze
H 60 cm

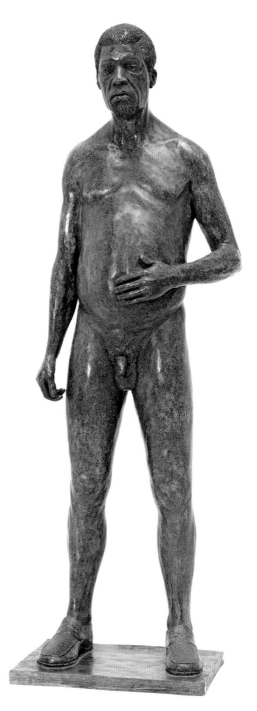

Denise de Cordova
Western
Mixed media
H 84 cm

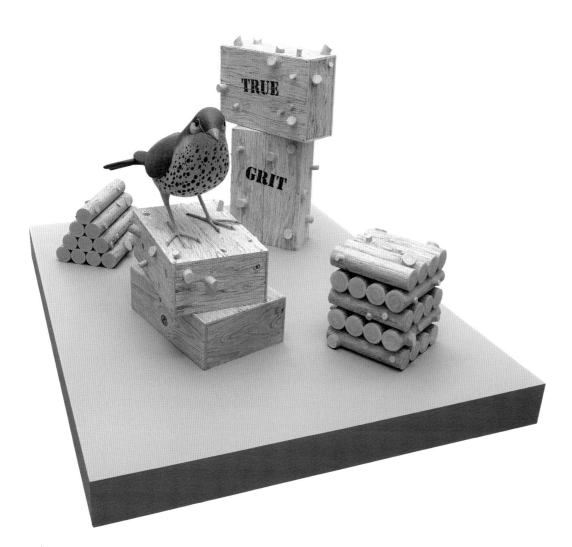

Bill Woodrow RA
Revelator 5
Bronze and laminated MDF
H 157 cm

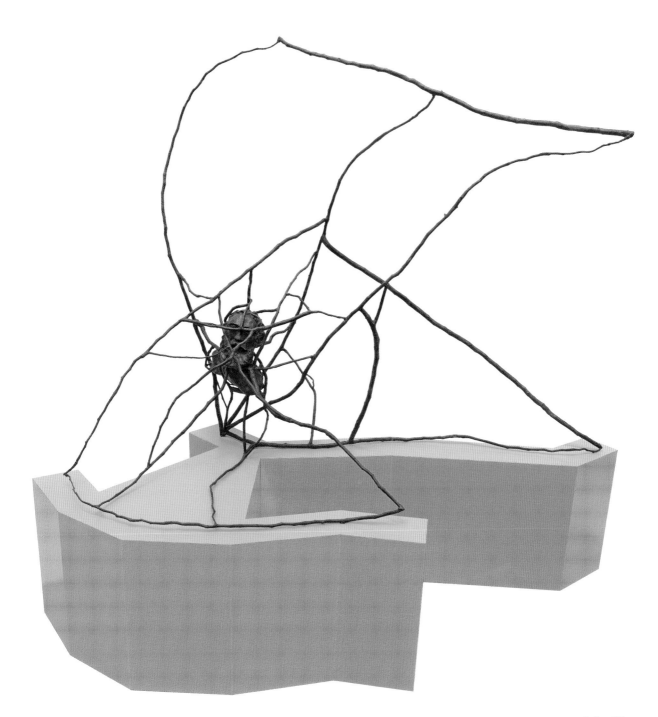

Jennifer Durrant RA
From a Series: Ghirlanda, No. 1 – Primo
Acrylic
116 × 61 cm

Kenneth Draper RA
Desert Light
Pastel
40 × 35 cm

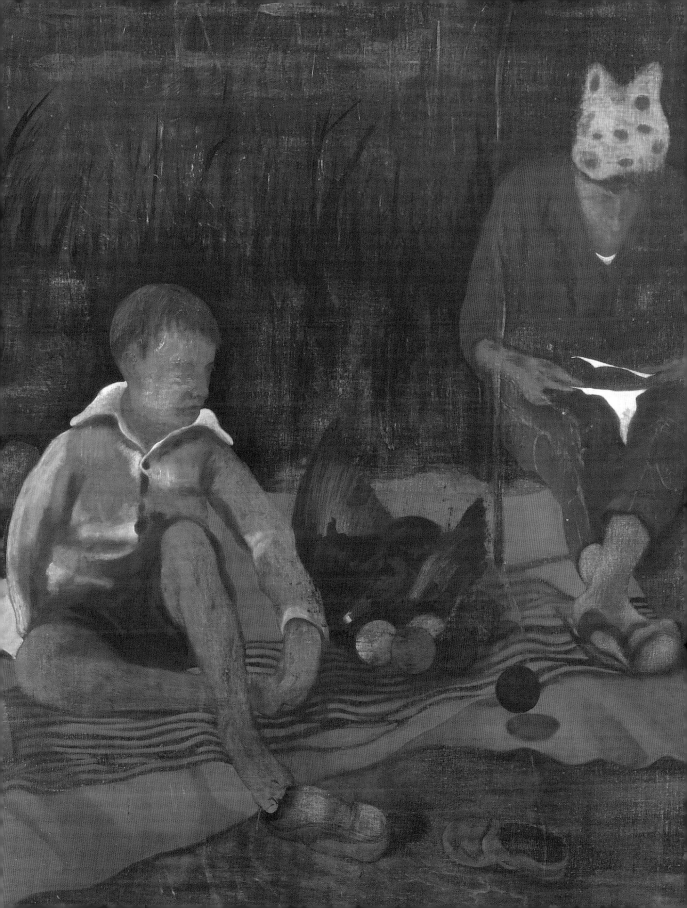

Prof Dhruva Mistry CBE RA
Maya Medallion I, 2010
Acrylic
54 × 54 cm

Rose Wylie
Green Bat
Oil
188 × 176 cm

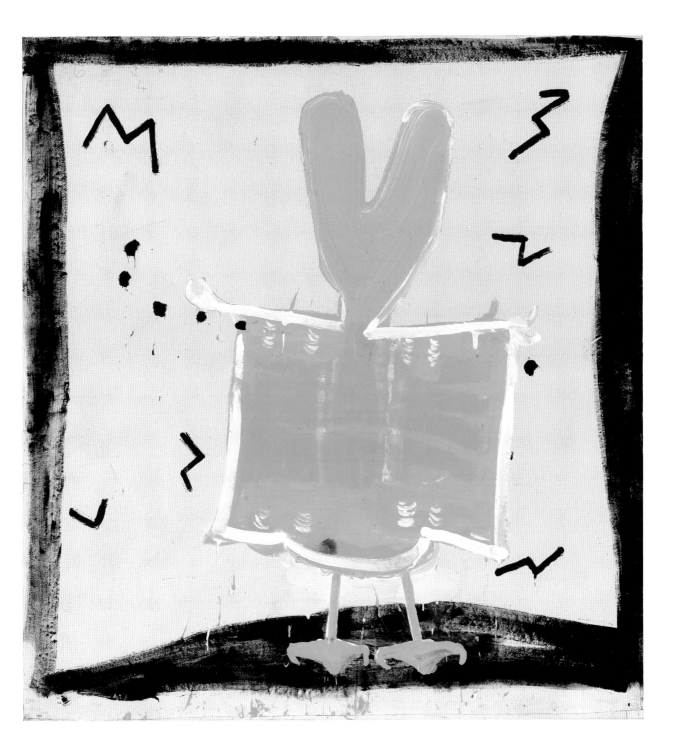

Simon Burton
Vicious Circle
Oil
180 × 240 cm

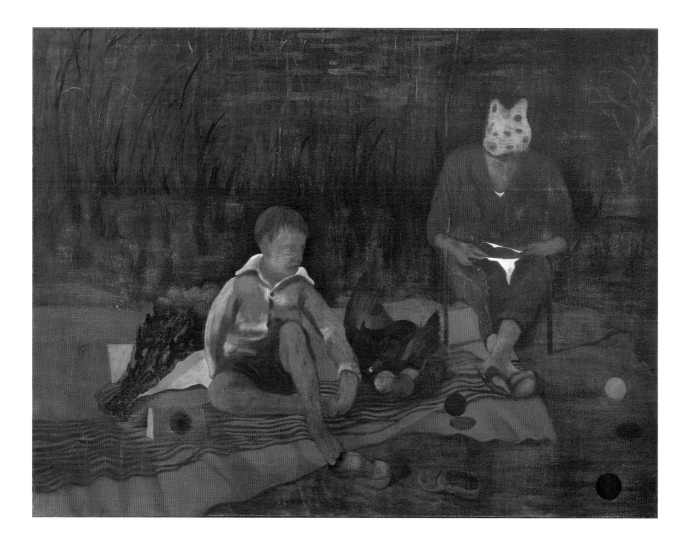

Tracey Emin RA
But I Think I Love You
Acrylic
183 × 183 cm

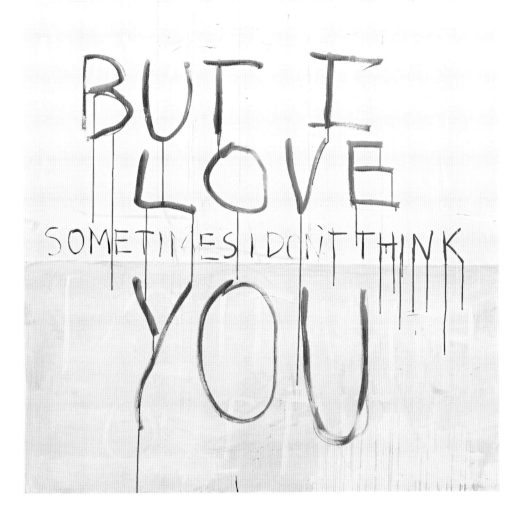

Ben Levene RA
Oak Tree, End of Paddock with Hay Field
Oil
61 × 51 cm

Prof Ken Howard RA
Raw War. We Are Making a Better World
Oil
125 × 227 cm

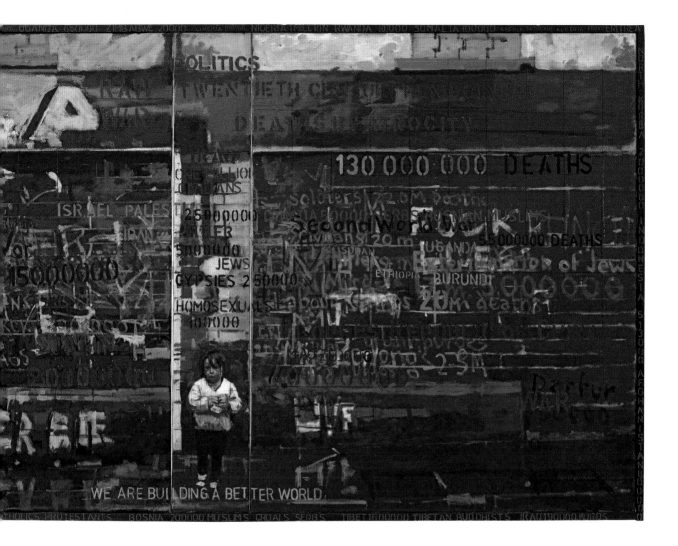

Anthony Green RA
Mary Mary Quite Contrary How Does Your Husband Grow…?
Oil
14 × 19 cm

Prof Ian McKeever RA
Standing I
Etching
44 × 32 cm

Dr Leonard McComb RA
Woman Carrying Tulips
Watercolour
241 × 190 cm

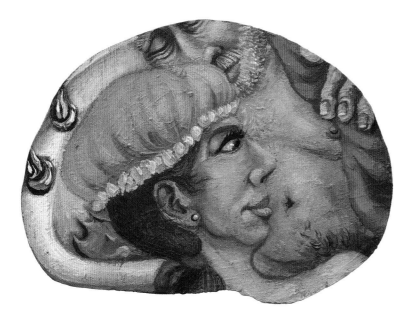

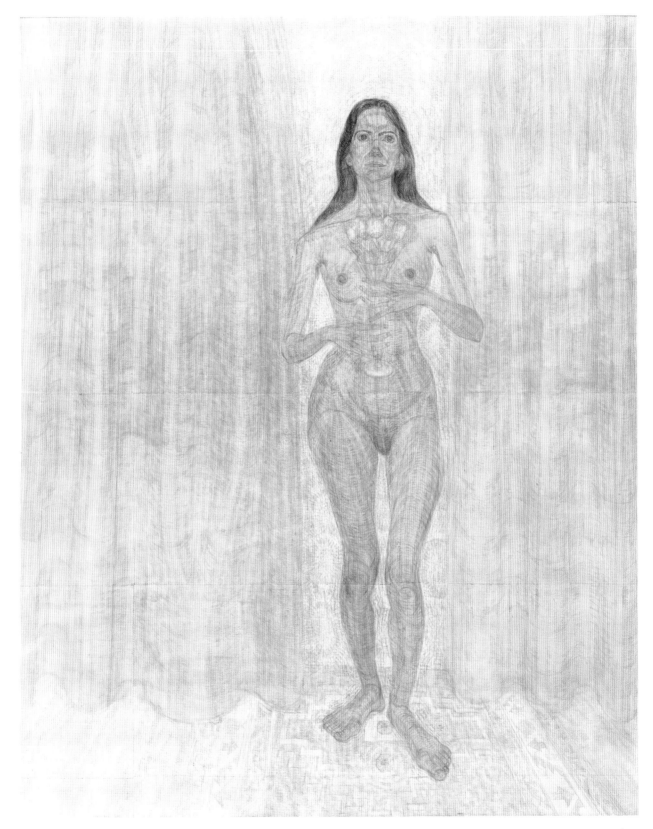

Anthony Eyton RA
Kata Tjuta (The Olgas), Midday, Australia
Oil
100 × 130 cm

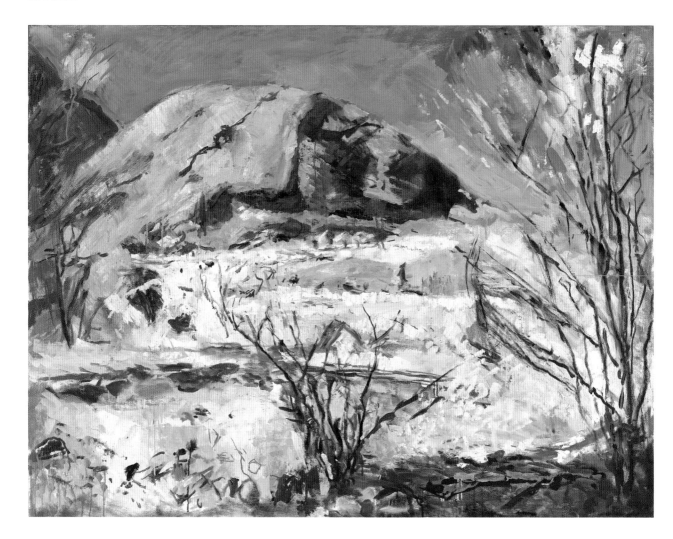

William Bowyer RA
The Cry on the Classical Bridge
Oil
100 × 125 cm

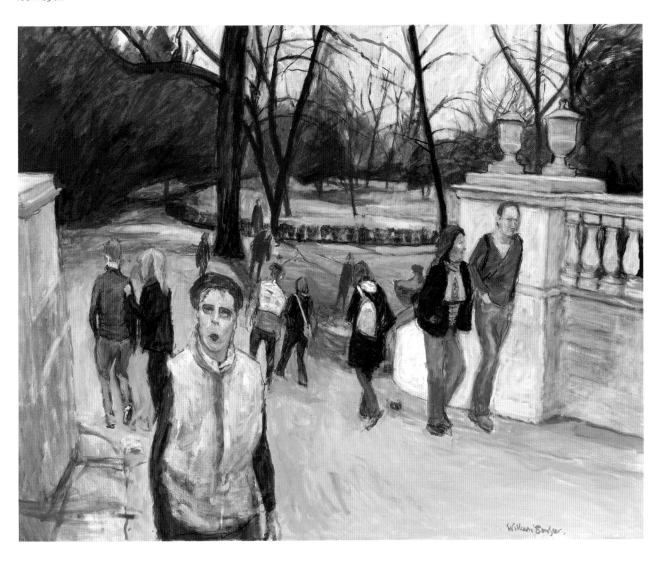

Frederick Cuming RA
Old Friend in the Sun
Oil
141 × 141 cm

Philip Sutton RA
In the Scented Breeze
Oil
196 × 127 cm

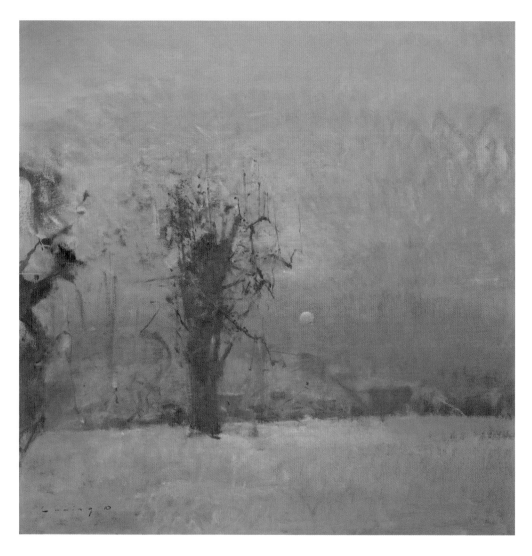

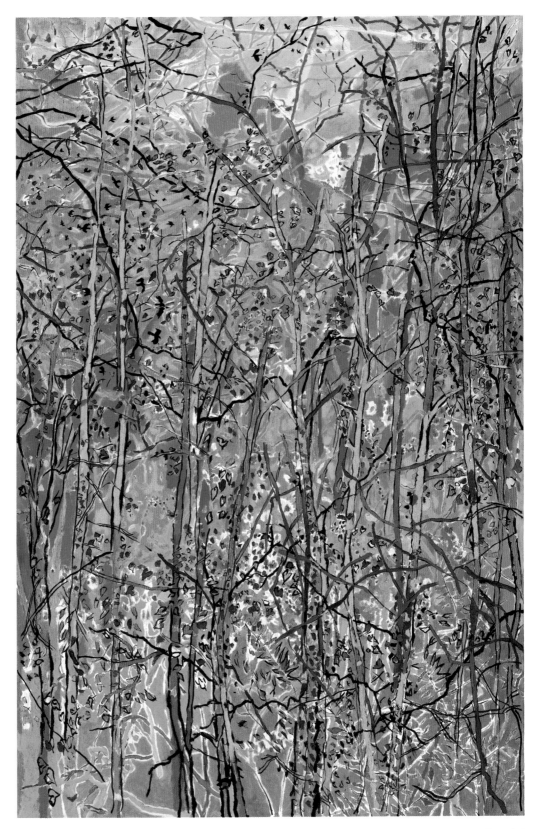

LECTURE
ROOM

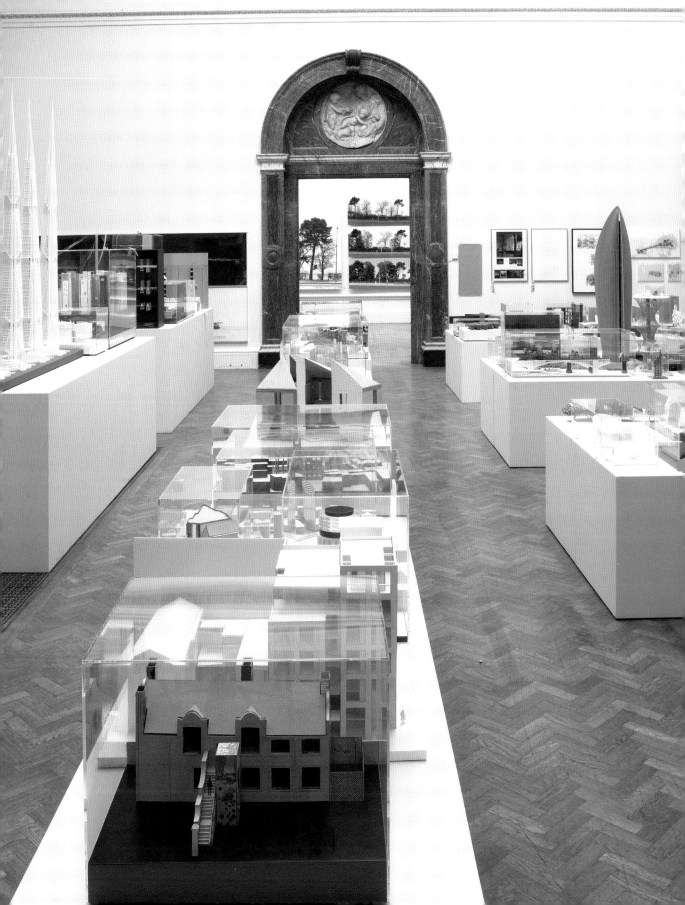

Paul Koralek CBE RA
Civic Centre Context Sketch
Ink
14 × 21 cm

Piers Gough CBE RA (CZWG Architects LLP)
Rainbow II, Student Residence, Isledon Road, N7
Pencil
54 × 81 cm

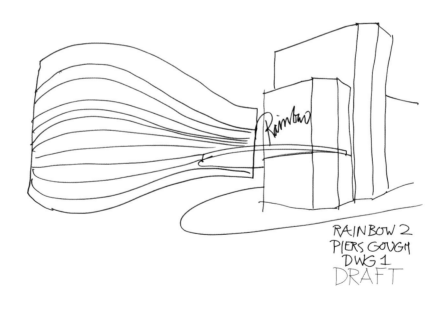

Leonard Manasseh OBE RA
Trees, Flowers and Heavenly Bodies
Ink
26 × 21 cm

Prof Ian Ritchie CBE RA
Landmark Wales
Etching
17 × 21 cm

**Lord Rogers of Riverside CH RA
(Rogers Stirk Harbour + Partners)**
Sydney Hotel, Australia
Model
H 25 cm

Renzo Piano Hon RA
*The Art Institute of Chicago – The Modern Wing
(Façade and Roof Study)*
Model
H 92 cm

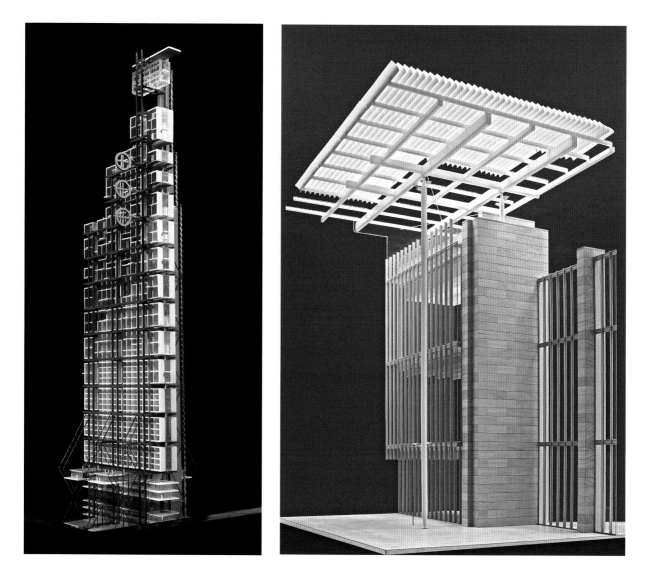

Spencer de Grey CBE RA (Foster and Partners)
NBK Headquarters, Kuwait
Model
H 160 cm

Lord Foster of Thames Bank OM RA (Foster and Partners)
India Tower, Mumbai
Models
H 196 cm

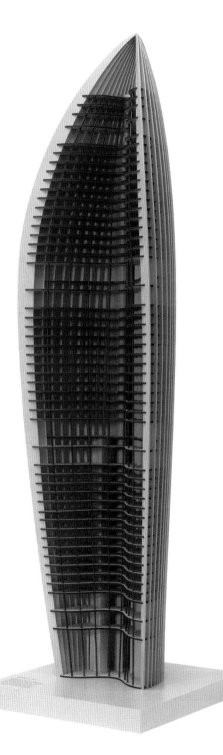

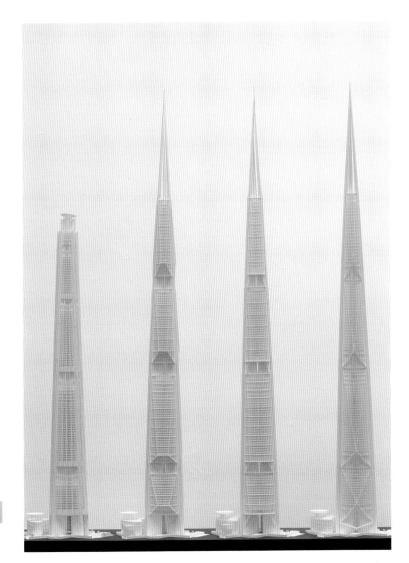

Sir Michael Hopkins CBE RA (Hopkins Architects)
Velodrome Study Model
H 51 cm

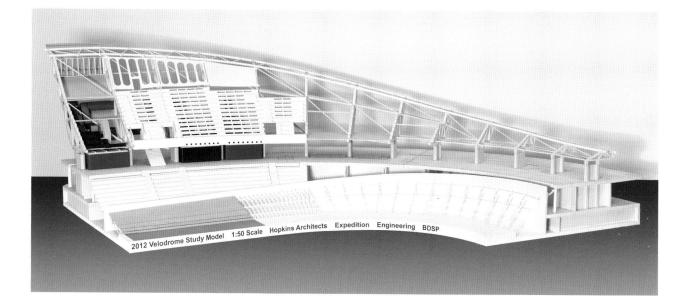

6A Architects
*Mines Park Model, a New English
Country House*
H 60 cm

Chris Wilkinson OBE RA
Salford Bridge
Model
H 29 cm

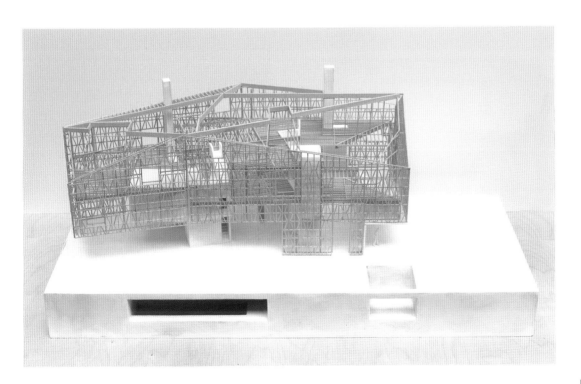

Michael Manser CBE RA (The Manser Practice)
Working Model for High- and Low-level Additions to the Sheraton Park Tower
Model
H 46 cm

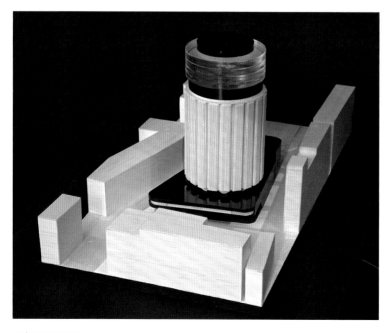

Caruso St John Architects LLP
Stadtraum HB, Zurich
Model
H 165 cm

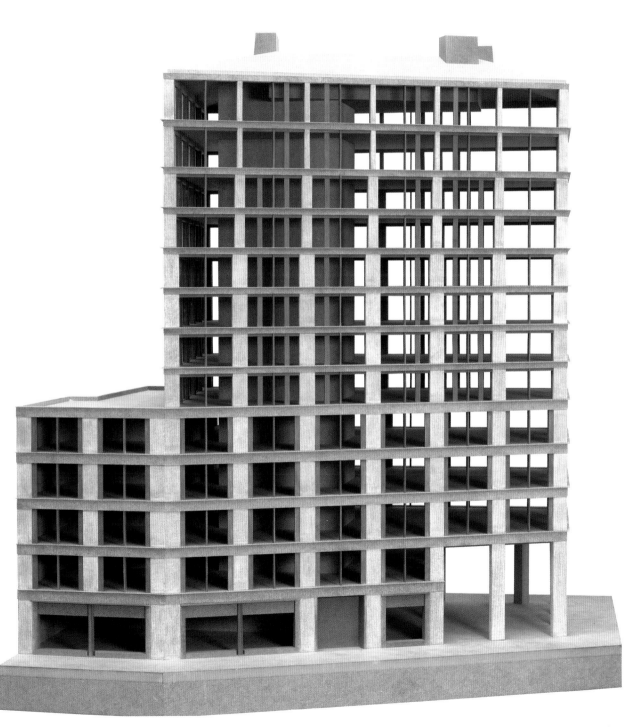

Eric Parry RA
Holburne Museum (detail)
Pen
85 × 68 cm

Eva Jiricna CBE RA (Eva Jiricna Architects)
Node Prototype Stage 1, Orangery, Prague
Photograph
30 × 42 cm

Sir Richard MacCormac CBE RA (MJP Architects)
View of House at Wolf's Cave, Jersey
Computer-generated image

Prof Trevor Dannatt RA
Private House, Terwick Wood, West Sussex (detail)
Mixed media
83 × 58 cm

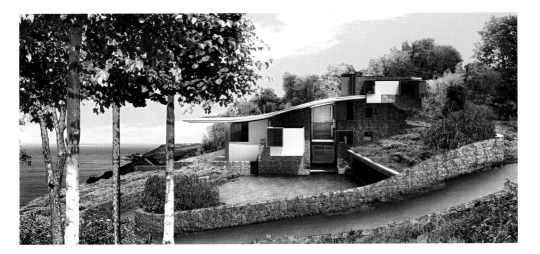

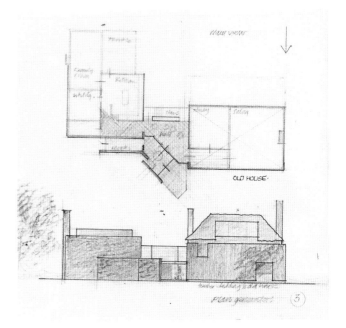

Edward Cullinan CBE RA
A Study for Shahat Garden City, Libya (detail)
Print
79 × 59 cm

Prof Sir Peter Cook RA
Swiss Cottage Tower
Mixed media
200 × 70 cm

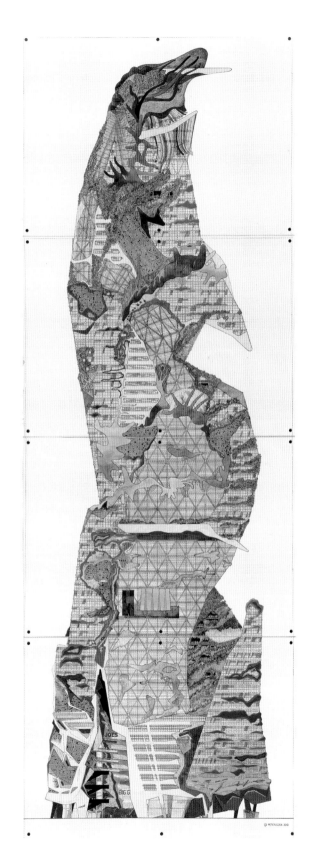

Zaha Hadid CBE RA (Zaha Hadid Architects)
Vision for Madrid (Relief 3)
Card
56 × 86 cm

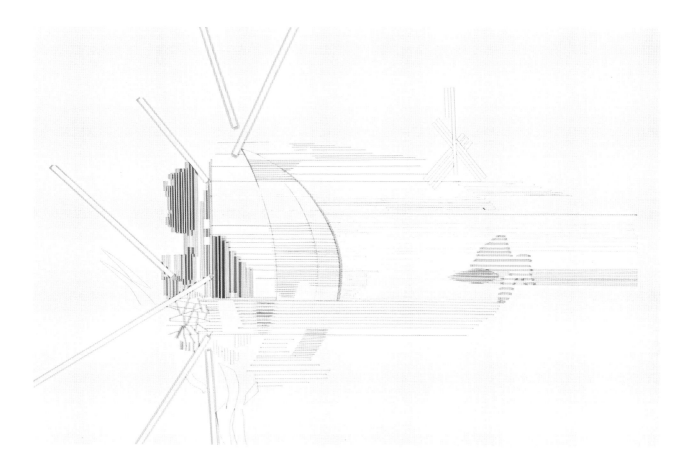

Prof Gordon Benson OBE RA (Benson + Forsyth)
Mort 1
Print
28 × 39 cm

WOHL CENTRAL HALL

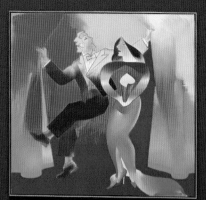

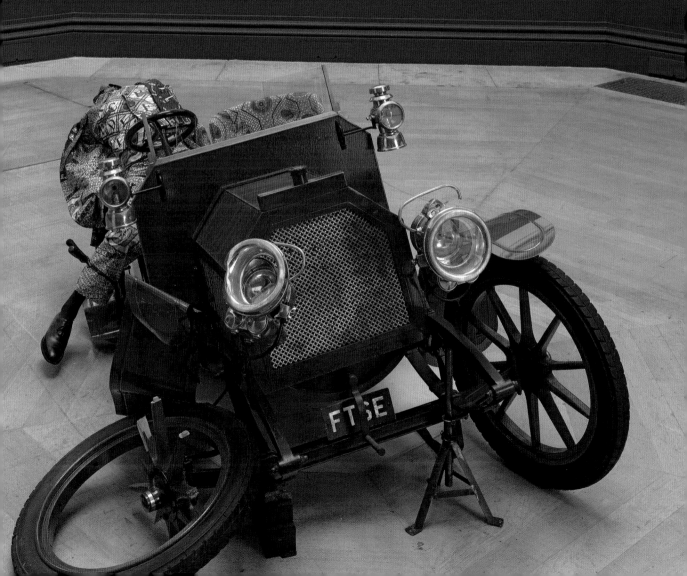

Eileen Cooper RA
Real World
Oil
137 × 153 cm

Lisa Milroy RA
All That Jazz
Oil
180 × 230 cm

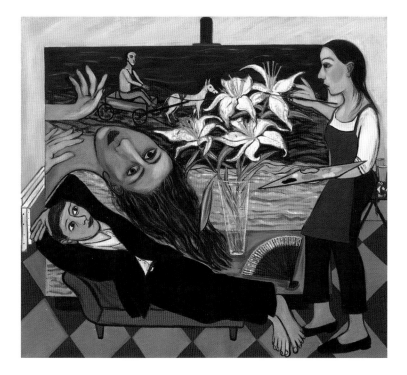

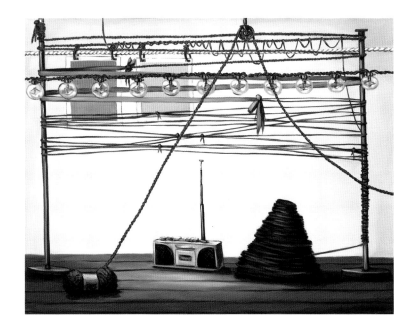

David Remfry MBE RA
Untitled
Watercolour and graphite
149 × 203 cm

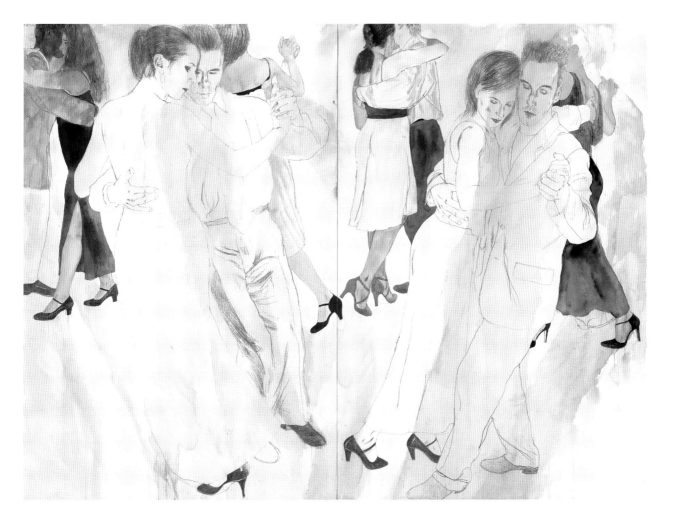

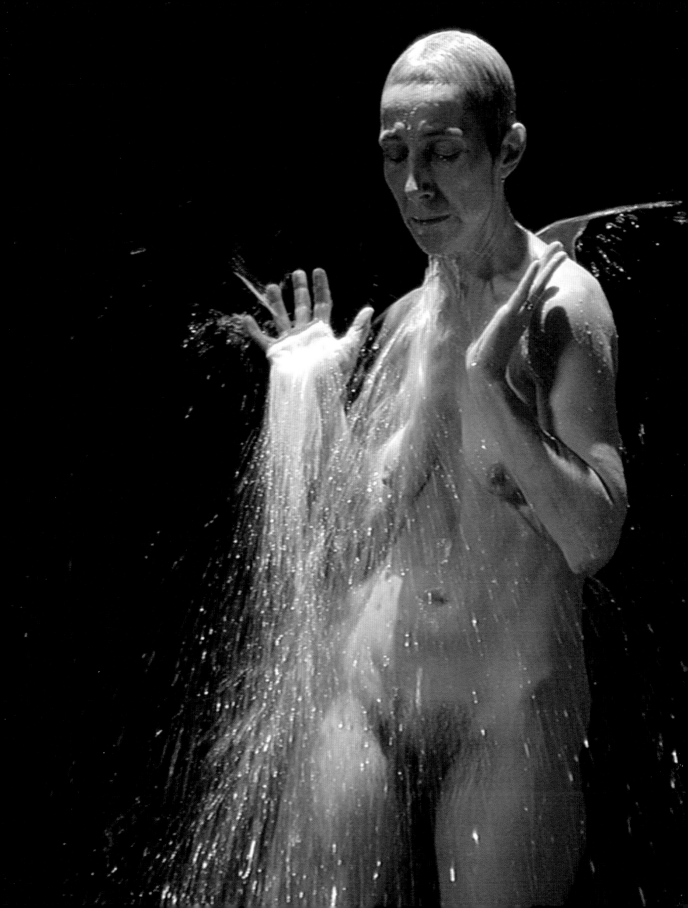

Paul Murphy
Untitled
C–type print
70 × 90 cm

Peter Abrahams
Galvanised II
Archival pigment inkjet print
120 × 94 cm

Louise Carreck
Barcelona Series No. 2
Photographic print
72 × 96 cm

Julian Opie
View of Loop Bridge Seen from Route 41 in the Seven Falls Area
3D lenticular acrylic
87 × 121 cm

Anne Charnock
Robert
Giclée on Somerset paper
90 × 110 cm

Allen Jones RA
Undressed Hatstand
Photograph
83 × 123 cm

Index

Royal Academy of Arts

The Royal Academy of Arts has a unique position as an independent institution led by eminent artists and architects whose purpose is to promote the creation, enjoyment and appreciation of the visual arts through exhibitions, education and debate. The Royal Academy receives no annual funding via government, and is entirely reliant on self-generated income and charitable support.

You and/or your company can support the Royal Academy of Arts in a number of different ways:

- Almost £60 million has been raised for capital projects, including the Jill and Arthur M Sackler Wing, the restoration of the Main Galleries, the restoration of the John Madejski Fine Rooms, and the provision of better facilities for the display and enjoyment of the Academy's own collections of important works of art and documents charting the history of British art.
- Donations from individuals, trusts, companies and foundations also help support the Academy's internationally renowned exhibition programme, the conservation of the Collections and education projects for schools, families and people with special needs; as well as providing scholarships and bursaries for postgraduate art students in the Royal Academy Schools.
- As a company, you can invest in the Royal Academy through arts sponsorship, corporate membership and corporate entertaining, with specific opportunities that relate to your budgets and marketing or entertaining objectives.

- If you would like to preserve the Academy for future generations, please consider remembering us in your will. Your gift can be a sum of money, a specific item or a share of what is left after you have provided for your family and friends. Any gift, large or small, could help ensure that our work continues into the future.

To find out ways in which individuals can support this work, or a specific aspect of it, please contact Ian Vallance on 020 7300 5624.

To explore ways in which companies, trusts and foundations can become involved in the work of the Academy, please contact Michael Eldred on 020 7300 5979.

For more information on remembering the Academy in your will, please contact Stacey Edgar on 020 7300 5677 or legacies@royalacademy.org.uk

Membership of the Friends

The Friends of the Royal Academy was founded in 1977 to support and promote the work of the Royal Academy. It is now one of the largest such organisations in the world, with around 90,000 members.

As a Friend you enjoy free entry to every RA exhibition and much more…

- Visit exhibitions as often as you like, bypassing ticket queues
- Bring a family adult guest and up to four family children, all free
- See exhibitions first at previews

- Keep up to date with RA Magazine
- Have access to the Friends Room

Why not join today?

- At the Friends desk in the Front Hall
- Online at www.royalacademy.org.uk/friends
- Ring 020 7300 5664 any day of the week

Support the foremost UK organisation for promoting the visual arts and architecture, which receives no regular government funding. *Please also ask about Gift Aid.*

Summer Exhibition Organisers
Alice Bygraves
Chris Cook
José da Silva
Edith Devaney
Lorna Dryden
Laura Egan
Katherine Oliver
Paul Sirr

Royal Academy Publications
David Breuer
Beatrice Gullström
Carola Krueger
Sophie Oliver
Peter Sawbridge
Nick Tite

Book design: 01.02
Photography: John Bodkin, DawkinsColour
Colour reproduction: DawkinsColour
Printed in Italy by Graphicom

British Library
Cataloguing-in-publication Data
A catalogue record for this book
is available in the British Library

ISBN 978-1-905711-87-1

Illustrations

Page 2: David Nash OBE RA, Raw Elm Frame
Page 4: The late Barry Flanagan OBE RA, *Large Left-handed Drummer*, next to the sculpture of Sir Joshua Reynolds PPRA by Alfred Drury RA in the Annenberg Courtyard
Page 7: Dr John Bellany CBE RA, *Celtic Allegory* (detail)
Pages 12–13: The late Barry Flanagan OBE RA, *Large Left-handed Drummer* (detail)
Page 21: Terry Setch RA, *Landfill* (detail)
Page 33: Installation in Gallery II. Foreground: David Nash OBE RA, *Raw Elm Frame*
Page 41: Large Weston Room before Sanctioning Day
Page 75: Stephen Chambers RA, *Hound/Reflecting* (detail)
Page 97: Installation in Gallery IV. Foreground: Gary Webb, *Flashy*
Pages 102–03: Installation in Gallery IV. Foreground: Gary Webb, *Flashy*. Background, from left to right: Rina Banerjee, *For the entire city a fragile hostility dazzling silks and no constraints*; Ansel Krut, *Exotic Dancer*; Rosson Crow, *Poverty Partye at the White House*
Page 111: Sarah Lucas, *John* (detail)
Page 114: Installation in Gallery V. On the wall: Prof Norman Ackroyd CBE RA, *Galapagos – An External Mural for the Sainsbury Laboratory, University of Cambridge, for the Study of Plant Development*; Sculptures, from left to right: John Maine RA, *Strata*; Jonathan Trayte, *Standing Nude (Blue)*; Paul Amey, *Winter Lake*; Geoffrey Clarke RA, *Portal I (maquette)*, *Germination* and *Portal II (maquette)*
Page 125: Mali Morris RA, *Flotilla* (detail)
Pages 130–31: Installation in Gallery VI. Centre: Anselm Kiefer Hon RA, *Einschüsse*
Page 137: David Mach RA, *Silver Streak*
Page 147: Simon Burton, *Vicious Circle* (detail)
Page 157: Katie Pratt, *Ackney* (detail)
Page 179: Installation in the Wohl Central Hall. Foreground: Yinka Shonibare MBE, *Crash Willy*
Page 183: Bill Viola, *Acceptance* (video still)

Photographic Credits

Pages 11 (top), 84 (top): Courtesy Eagle Gallery, London
Pages 24, 141: © The artist. Courtesy Hales Gallery
Page 26: Courtesy The Fine Art Society plc
Pages 38, 95: © The artist. Courtesy the artist and Victoria Miro Gallery, London
Page 39: © The artist. Courtesy Hales Gallery, London
Page 79: © Gillian Ayres. Courtesy Alan Cristea Gallery
Page 85 (bottom): © Purdy Hicks Gallery, London
Page 88: David Hockney and Jonathan Wilkinson. © David Hockney
Page 92 (right): © The Estate of Nancy Spero. Courtesy Anthony Reynolds Gallery
Page 93: Courtesy the artist. Photo: Hugh Glendinning
Pages 97, 102–03 (Gary Webb): Courtesy The Approach, London
Page 98: © The artist. Courtesy Stuart Shave/Modern Art, London
Page 99: © The artist. Courtesy Timothy Taylor Gallery, London
Page 100: Courtesy Galerie Gebr. Lehmann, Berlin/Dresden. Photo: Werner Lieberknecht, Dresden
Page 101 (top): © Hiroe Saeki 2009–10. Courtesy Taka Ishii Gallery
Page 101 (bottom): © The artist. Courtesy Stuart Shave/Modern Art, London
Pages 102–103: Nigel Cooke/Ansel Krut © The artists. Courtesy Stuart Shave/Modern Art, London; Rina Banerjee © The artist. Courtesy Haunch of Venison
Pages 104–05 (Dan Perfect): Courtesy the artist. Photo: Antony Makinson
Page 106: © Cecily Brown. Courtesy Gagosian Gallery. Photo: Robert McKeever
Page 107: © Fiona Rae. Courtesy Timothy Taylor Gallery, London
Page 108: © The artist. Courtesy Sadie Coles HQ, London
Page 109: © Glenn Brown. Courtesy Gagosian Gallery. Photo: Prudence Cuming Associates Ltd
Pages 111, 119 (bottom): © Sarah Lucas. Courtesy Sadie Coles HQ, London
Page 117: © The artist. Courtesy Flowers, London
Pages 129, 130–31 (Callum Innes): Courtesy the artist and Frith Street Gallery, London
Page 135: © Rosa Loy 2010. Courtesy Schlechtriem Brothers, Berlin. Photo: VWE Wacter
Page 151: © The artist
Page 166 (right): Renzo Piano Building Workshop
Page 179 (Yinka Shonibare): © The artist. Courtesy the artist and Stephen Friedman Gallery, London
Page 183: Performer: Weba Garretson. Photo: Kira Perov
Page 185 (bottom): Courtesy Emma Hill, Eagle Gallery